THIS I BELIEVE

PHILADELPHIA

Edited by
Dan Gediman *and*
Mary Jo Gediman *with*
Elisabeth Perez-Luna

THE
History
PRESS

Published by The History Press

Charleston, SC 29403

www.historypress.net

Copyright © 2015 by This I Believe, Inc.

All rights reserved.

This I Believe® is a registered trademark of This I Believe, Inc.

Front cover: The Carol M. Highsmith Archive, Library of Congress, Prints and
Photographs Division
Back cover: ©2009 City of Philadelphia Mural Arts Program/Eric Okdeh, Kien
Nguyen, and Michelle Angela Ortiz

First published 2015

Manufactured in the United States

ISBN 978-1-46711-897-2

Library of Congress Control Number: 2015947039

To Margot Trevor Wheelock,
who was responsible for
This I Believe

Contents

Contents

Contents

Contents

CONTENTS

Contents

Foreword

My Dad and This I Believe

KEITH WHEELOCK

THIS I BELIEVE IS A PHILADELPHIA STORY. THAT IS WHERE MY
father, Ward Wheelock, took a powerful idea and, based in
Philadelphia, brought This I Believe to countless millions
throughout America and globally.

Dad lived in the Philadelphia area his entire life, except
for his time at Cornell and serving in World Wars I and
II. The seed of This I Believe was planted at the Church of
the Redeemer in Bryn Mawr. My mother cut out a Joseph
Fort Newton article from the 1949 Easter Sunday church
program. Five days later, my mother died.

I was amazed by the impact that this Newton article had
on Dad. He had it inscribed on plaques that he gave to me,
my sister, and my brother. That was just the start of how
Dad transformed Newton's words into a memorial to my
mother by creating This I Believe:

> *We must take time, take pains, have a plan, form spiritual*
> *habits, if we are to keep our souls alive; and now is the time to*

begin…The same hard knocks come to him as to others, but he
reacts to them by the central law of his life. He suffers deeply,
but he does not sour. He knows frustration, but he goes right
on in his kindness and faith. He sees his own shortcomings, but
he does not give up, because a power rises up from his spiritual
center and urges him to the best.

—Joseph Fort Newton

Dad, a dynamic Philadelphia advertising executive, lived his personal credo: "Don't ask why, ask why not?" He also profoundly believed in the power of an idea. (In 1953, his idea about international fellowships led to the creation of Eisenhower Fellowships, which, headquartered in Philadelphia, is still flourishing more than six decades later.)

Dad often spoke with me about how everyone has beliefs that affect his or her life. He was convinced that there was a vast audience that would be eager to hear and be affected by the personal beliefs of others. He was clear that this would not be a religious program, though individuals could express their religious beliefs. At the outset, Dad assumed that people would express a belief in a Supreme Being. His only absolute guideline was that beliefs must reflect what a person believed in, not what he/she was against.

In 1949, Dad began exploring his idea of a radio program about beliefs with dozens of his Philadelphia friends and colleagues. They provided a sounding board that more sharply honed what swiftly began to emerge as This I Believe. A critical catalyst was Donald Thornburgh, general manager of WCAU, then Philadelphia's CBS TV and radio station. Thornburgh volunteered to pioneer *This I Believe* on WCAU.

Dad had met Edward R. Murrow in London during World War II. Subsequently, when Murrow returned to the United

States, Dad hired Murrow to host his first nightly CBS news program. (Murrow, a person of strong convictions, only permitted Campbell Soup—my dad's principal advertising account—ads at the start and conclusion of his evening broadcasts.) Murrow was captivated by the This I Believe concept. He volunteered to be the host of a daily *This I Believe* radio program, each episode of which would focus on a person reading his or her essay about their core beliefs. A major obstacle was to persuade CBS to broadcast these commercial-free, five-minute programs on its national radio network.

Dad, Murrow, and Thornburgh met with William Paley, the head of CBS, who was, himself, a native Philadelphian (indeed, CBS had been based in Philadelphia in its early years before moving to New York). Dad told me that, initially, Paley was a hard sell. Ultimately, Paley agreed that Thornburgh could test the Murrow-introduced programs on his Philadelphia CBS radio station.

The initial public response was stunning. Soon *This I Believe* was a regular feature on the entire CBS Radio network, reaching thirty-nine million listeners weekly. Dad ran the This I Believe operation from his Ward Wheelock Company office in the Lincoln-Liberty Building, adjacent to what once was the Philadelphia National Bank Building. A small editorial staff in New York oversaw the editing and recording of the actual programs.

Philadelphians provided a number of the initial essays that were broadcast. Some were included in the first This I Believe book, which was published by Simon and Schuster in 1952 and became, excluding the Bible, the best-selling nonfiction book of the year. This I Believe, while national, was also local. One of the young staffers in Dad's office suggested his dentist as a likely essayist. Thus,

a Philadelphia dentist joined hundreds of distinguished national individuals as a This I Believe contributor.

I was away at school, and then college, while Dad expanded the power of his idea nationally and internationally. I experienced some of Dad's enthusiastic conviction when I accompanied him on a visit with Louis B. Seltzer (editor of the *Cleveland Press*) in Cleveland and then, in 1953, to have tea with Professor Gilbert Murray in Oxford. Seltzer's essay was included in the first book. Professor Murray, in addition to writing his personal essay, wrote an essay in the voice of Socrates, as part of the "immortal" series on historical figures ranging from Socrates to Franklin Roosevelt, which were included in a second book of essays and a Columbia record.

Dad was convinced that This I Believe had a universal message. Both British and Arabic This I Believe books were published, intended as forerunners of a book in Urdu. *This I Believe* segments were translated into six languages and broadcast around the world on the Voice of America. There was also a regular Armed Forces Radio Service feature. In early 1954, Dad took a world trip to expand the reach of This I Believe (and to introduce the Eisenhower Fellowships).

In 1954, I wrote my own This I Believe essay that was broadcast and published in papers throughout the United States. That same year, This I Believe, after a meteoric rise, was abruptly terminated. Dad and other family members disappeared on a yacht in the Bermuda Triangle in January 1955.

I never lost faith in the power of Dad's idea. In 1992, when I commenced a twenty-two-year career as a college history professor, I taught a segment on the similarities and differences between early Judaism, Christianity, and Islam. With some trepidation, I had my students explore This I Believe and then write their own essays. I was astonished by the

result. Over the years, more than six hundred students wrote This I Believe essays. A number of students, whose writing skills seemed otherwise mediocre, wrote brilliant essays. Many said that it was their most meaningful college experience.

I thought that this might provide an opportunity to rekindle Dad's idea. I sent selections of my students' This I Believe essays to Janet Murrow. Mrs. Murrow suggested that I contact Joe Wershba, her husband's longtime colleague. After Wershba's enthusiastic response, I submitted my idea to Simon and Schuster. The response was that, without a Murrow-type personality, a new This I Believe book was a no-go.

Five years later, Dan Gediman called me, asking if I was the son of Ward Wheelock. Dan told me that he had read one of the This I Believe books and thought it was a natural for National Public Radio. I was thrilled by his passion for the power of Dad's idea. Dan and Jay Allison made it happen. I vividly remember a dinner with NPR's senior executives at which Ed Murrow's son Casey and I were asked to speak.

The new *This I Believe* was a public radio feature for years. The This I Believe website (thisibelieve.org) and a series of books spread the This I Believe message widely. Tens of thousands of personal essays poured in from across the country. Dan introduced This I Believe in many schools and colleges. I chose to introduce This I Believe to a senior citizen audience. I first led a four-week This I Believe program for residents in New Jersey's Somerset and Hunterdon Counties. The wait list was large, as we limited the program size to thirty-five participants. I used a series of This I Believe broadcasts prepared by Dan's Louisville office, which also provided a history of This I Believe CD. The enthusiastic response was such that I was obliged to extend the program another two weeks.

Subsequently, I have conducted nine additional This I Believe programs for "mature participants" in both New Jersey and on Long Island. For me, this has demonstrated that This I Believe resonates with both young and old. Several of my more outspoken participants were in their nineties.

I am heartened that the power of Dad's idea is as vital today as it was over six decades ago. I applaud Dan and Mary Jo Gediman for making this happen. I can't imagine a more fitting tribute to what Dad initiated than to celebrate This I Believe in Philadelphia, where it all began.

Introduction

Dan Gediman

I FIRST HEARD OF THIS I BELIEVE IN MARCH 2003. I WAS AT home, sick with the flu, and starting to get bored. I had read everything on my bedside table and was looking for something else to keep me occupied. I found a book on my wife's bookshelf that I had somehow never seen before. It was called *This I Believe*. I was intrigued by the words on the spine: "Written for Edward R. Murrow."

At first glance, I thought a fifty-year-old book filled with "the living philosophies of one hundred men and women in all walks of life" might be dry and dated. But I was wrong. I quickly became absorbed in the book. Not only was the content on these pages fascinating to me, but the *idea* behind the pages captivated me, as well—that all of these writers had dug deeply inside themselves to discern what they truly believed—and then had the courage to share it with the world.

The idea for This I Believe was born in 1949 at a business lunch attended by four powerful men: advertising executive Ward Wheelock; William S. Paley, the founder and CEO of

CBS; Donald Thornburgh, the station manager of WCAU, the Philadelphia CBS affiliate; and Edward R. Murrow, arguably the most famous—and most respected—broadcaster in the world at that time. Wheelock was the instigator of the luncheon, inspired to memorialize his late wife, Margot, by creating something significant in her honor.

Wheelock had a long history with the other men at the table. His ad agency held the Campbell Soup account, which sponsored several high-profile programs on the CBS Radio network. Wheelock's relationship to CBS, and to Paley, was cemented when he convinced Campbell Soup to sponsor Orson Welles's *Mercury Radio On the Air* after its infamous October 1938 broadcast of *The War of the Worlds*, becoming *The Campbell's Playhouse* later that year.

Wheelock had first met Edward R. Murrow in London, when Murrow was the chief European correspondent for CBS. After World War II, Wheelock offered CBS a Campbell Soup–sponsored evening news program to be hosted by Murrow.

At this 1949 luncheon, according to the recollections of Wheelock, the men bemoaned the spiritual state of the nation—that "material values were gaining and spiritual values were losing." They blamed a combination of factors, including "the uncertainty of the economic future, the shadow of war, the atom bomb, army service for one's self or loved ones, the frustration of young people facing the future."[1] To help counter this trend, the group decided to produce a daily, commercial-free, five-minute radio program that would feature a successful man or woman sharing his or her personal philosophy—the guiding beliefs by which they led their lives. The hope was that these programs would be provocative, stimulating, and helpful to listeners. The plan was that Murrow would introduce each program, and

1. From a pamphlet entitled *This I Believe*, copyright 1951, Help Inc.

Wheelock would act as its executive producer and its sole funder, working through a nonprofit organization that he created just to facilitate the production of the series. Thornburgh would debut the series as a local feature on his radio station, and Paley would offer it to his entire network of CBS Radio affiliates if it first succeeded in the Philadelphia market. And succeed it did!

Almost from the day the series first aired in March 1951, the response from Philadelphians was enormous and overwhelmingly positive. Indeed, before too long, Wheelock had assigned two women at his agency the task of answering the daily mail. As the popularity of the series quickly spread, stations around the country clambered to carry it in their markets. Eventually, some 196 stations around the country aired essays at least once daily during the week, sometimes two or more times on the weekend. In addition, This I Believe reached Americans through their daily newspapers as more than ninety papers throughout the nation published "This I Believe" pieces, usually as a weekly feature. And within days of the series' launch, Wheelock was approached by several major publishers interested in creating an anthology of essays in book form.

When the smoke cleared, Simon and Schuster won the bidding war, and in 1952, the first of two volumes of This I Believe essays was published. It was an immediate success, selling out its first printing in a matter of days. It went on to sell more than 300,000 copies in hardcover, an enormous number for that time. In addition, Columbia Records released a two-record set of This I Believe essays, which was also a bestseller. Educators were also drawn to This I Believe, assigning their students to write their own essays, some of which ended up being broadcast on the radio series.

Prompted by interest from the U.S. State Department, the series quickly spilled over the U.S. borders and became an international phenomenon through Voice of America

broadcasts heard around the globe. At its peak, the international weekly listenership was estimated at thirty-nine million, and additionally, dozens of newspapers and magazines around the world carried This I Believe essays in translation. Service people overseas, including those seeing action in the Korean War, were able to listen to *This I Believe* on the Armed Forces Radio Service and to read weekly This I Believe essays in *Stars and Stripes*, the military's daily newspaper. There was even a This I Believe essay contest among military personnel, with the winners' essays published in *Stars and Stripes.*

Despite the increasing popularity of *This I Believe*, the radio series came to an abrupt end following two back-to-back blows to the Wheelock family. In early 1954, the Campbell Soup Company pulled its business from Ward Wheelock's advertising agency. At the time, Campbell accounted for the vast majority of the agency's revenues. Without this income, Wheelock was no longer able to bankroll the radio series, and efforts to find foundation funding to replace his personal philanthropy failed.

The final blow came in January 1955 when Wheelock; his new wife, Marie; and his eldest son, Ian, took a Caribbean cruise on his yacht. On January 18, 1955, the boat disappeared in the Bermuda Triangle and, with it, any chance that the *This I Believe* series would continue.

In the wake of these events, Murrow agreed to pay out of his pocket the necessary expenses to finish production on the handful of remaining essays, and in April 1955, *This I Believe* released its last program and slowly receded into obscurity.

By the time I encountered that *This I Believe* book in 2003, it was long out of print and the radio program that inspired it was almost completely forgotten. Nonetheless, when my colleague Jay Allison and I approached National Public Radio top programming executive Jay Kernis in late 2003 to see if he might be interested in a new version of *This I Believe*, we were

delighted to learn that he knew all about it. A former CBS Television producer, Kernis also owned one of the out-of-print *This I Believe* books and had been looking at his copy just days before receiving our proposal, thinking to himself that it would be great to bring it back to life as a public radio program.

And so, in April 2005, with the Corporation for Public Broadcasting taking the place of Ward Wheelock as our main funder, and Jay Kernis taking over the role of William S. Paley, we debuted the new edition of *This I Believe* on National Public Radio. And almost immediately, we began to experience an uncanny re-creation of what happened to the producers of the original series.

As was the case in 1951, the first week we were on the air, we were approached by more than a dozen major publishers who were also interested in anthologizing our radio programs in print form. Our first book, *This I Believe: The Personal Philosophies of Remarkable Men and Women*, was a *New York Times* bestseller, has been translated into six languages, and has sold more than 500,000 copies to date. We have published seven additional books, including an anthology of 1950s essays and four books of essays arranged by theme—on the subjects of love, fatherhood, motherhood, and life lessons.

Just like in the 1950s, the State Department eventually showed interest in the power of This I Believe as a tool for grass-roots diplomacy—a way for Americans and citizens of other countries to recognize their shared humanity. And even before we debuted on NPR, educators approached us, wanting This I Believe—based curricula for teaching the essay assignment in their classrooms.

The main difference between the original This I Believe project and ours is that in the 1950s, all essayists appearing on the radio broadcasts were handpicked and personally commissioned to write essays. They each received formal,

embossed invitations along with specially created long-playing records of other people's essays to inspire them. Our idea was very different. From our very first broadcast, we encouraged all radio listeners and the general public to send in their own essays, directing them to our website for instructions on how to write one. Over the past decade, we have received more than 150,000 essays from every state of the union and nearly one hundred countries around the world.

In 2013, our nonprofit organization, This I Believe, Inc., launched a new venture—collections of essays from particular cities or states. We began, as Ward Wheelock did, in our own backyard, publishing the first local anthology in Kentucky, where our offices are located. The runaway success of *This I Believe: Kentucky* led to our being contacted by The History Press, the nation's foremost publisher of books of local interest. They expressed a desire to publish a series of local This I Believe anthologies, and after a discussion of which location to launch this new series, our choice was immediate—Philadelphia, the birthplace of This I Believe.

Today, as our organization follows in the giant footsteps of Ward Wheelock, Edward R. Murrow, and their This I Believe staff, we are constantly reminded of the legacy we have inherited. We consider ourselves stewards of this powerful idea, not only in showcasing the beliefs of a new generation but also in allowing people to read the inspiring and still timely words of their parents' and grandparents' generation. The book you are holding in your hand spans more than a century of Philadelphia's history. Many of the writers of the 1950s essays were coming of age during the nineteenth century, while the contemporary essays speak to issues still current as I write this in 2015. My hope is that you will be as amazed as I am at how eloquently these essays speak to us across the decades—and help us think about our own beliefs.

Section I

FROM THE 1950S RADIO SERIES

A Ball to Roll Around

ROBERT ALLMAN

I LOST MY SIGHT WHEN I WAS FOUR YEARS OLD BY FALLING OFF
a boxcar in a freight yard in Atlantic City, New Jersey, and
landing on my head. Now, I am thirty-two. I can vaguely
remember the brightness of sunshine and what color red is. It
would be wonderful to see again. But a calamity can do strange
things to people.

It occurred to me the other day that I might not have
come to love life so, as I do, if I hadn't been blind. I believe
in life now. I am not so sure that I would have believed in it
so deeply, otherwise. I don't mean that I would prefer to go
without my eyes. I simply mean that the loss of them made
me more appreciate what I had left.

Life, I believe, asks a continuous series of adjustments
to reality. The more readily a person is able to make these
adjustments, the more meaningful his own private world
becomes. The adjustment is never easy. I was bewildered
and afraid, but I was lucky. My parents and my teachers saw
something in me—oh, a potential to live you might call it—

which I didn't see. And they made me want to fight it out with blindness.

The hardest lesson I had to learn was to believe in myself. That was basic. If I hadn't been able to do that, I would have collapsed and become a chair rocker on the front porch for the rest of my life. When I say *believe in myself*, I am not talking about simply the kind of self-confidence that helps me down an unfamiliar staircase alone. That is part of it, but I mean something bigger than that: an assurance that I am, despite imperfections, a real, positive person, that somewhere in the sweeping, intricate pattern of people, there is a special place where I can make myself fit. It took me years to discover and strengthen this assurance. It had to start with the most elementary things.

When I was a youngster, once a man gave me an indoor baseball. I thought he was mocking me, and I was hurt.

"I can't use this," I said.

"Take it with you," he urged me, "and roll it around."

The words stuck in my head: "Roll it around, roll it around." By rolling the ball, I could listen where it went. This gave me an idea—how to achieve a goal I had thought impossible: playing baseball. At Philadelphia's Overbrook School for the Blind, I invented a successful variation of baseball. We called it *groundball*.

All my life, I have set ahead of me a series of goals and then tried to reach them one at a time. I had to learn my limitations. It was no good to try for something I knew at the start was wildly out of reach, because that only invited the bitterness of failure. I would fail sometimes anyway, but on the average, I made progress.

I believe I made progress more readily because of a pattern of life shaped by certain values. I find it easier to live with myself if I try to be honest. I find strength in

the friendship and interdependence of people. I would be blind, indeed, without my sighted friends. And very humbly, I say that I have found purpose and comfort in a mortal's ambition toward godliness.

Perhaps a man without sight is blinded less by the importance of material things than other men are. All I know is that a belief in the higher existence of a nobility for men to strive for has been an inspiration that has helped me more than anything else to hold my life together.

ROBERT G. ALLMAN *was a lawyer and civic activist from Philadelphia. He became blind at the age of four, but he flourished at a school for the blind, learning "the things I could do instead of the things I couldn't." While at school, he developed a form of baseball called groundball that students at the school still play. Allman died in 1994 at the age of seventy-five.*

A Philosophy of Freedom and Social Responsibility

WALTER H. ANNENBERG

I FEEL HUMBLE WHEN I AM ASKED TO ADD SIGNIFICANCE FROM my own experience to the numerous ideas that have been advanced by inspired and divine leaders of old and recent times. But I also feel a tremendous and awe-inspiring kinship with these men of all ages who have uttered their beliefs, not only for themselves but for the benefit of all mankind. And I am impressed with the fact that through all these beliefs, as I see it, runs one great truth: the importance of the individual.

I believe in man, in his courage, his vision, his desire to do what is noble and best, his dependability. When daily I survey the newspaper with which I am associated, the *Philadelphia Inquirer*, I am impressed with the abundance of information that constantly testifies to the indomitable will of man. No disaster, not flood nor fire nor famine—no, not even war—can overcome him.

Because I trust in the essential greatness of man, it follows then that I believe that man must have an area of freedom in which to develop his fullest potentialities, including not only his creative ability but also that insignia of his maturity,

social responsibility. I believe in freedom because only when men have the freedom to seek truth can they work toward the kind of life they desire.

In the field of political freedom I stand for a state which never claims to have found the final truth and does not, therefore, stifle all other ideas. I stand for a government which expresses the free will of individuals and which is not a nation to which individuals are subservient. We should guard against the abridgement of freedom in our country, especially the vulnerable freedoms of press and of education. Present-day events, like the alarming suppression of *La Prensa*, warn us that these are the first freedoms to be attacked by dictators. And in the field of personal freedom, no irrational prejudice or discrimination should curb the rights—the equal rights—of all men.

I believe in social responsibility, that a man's service to others must be at least in ratio to the character of his own success in life. When one is fortunate enough to gain a measure of material well-being, however small, service to others should be uppermost in his mind. Freedom and social responsibility form the basis of my own personal philosophy. Upon them, I believe, depends the very dignity of man.

WALTER H. ANNENBERG *was a philanthropist, art collector, and former ambassador to the United Kingdom from 1969 to 1974. At one time, he presided over a vast communications empire that included* TV Guide *and the* Philadelphia Inquirer. *Annenberg's philanthropy was largely focused on education and the arts, including the establishment of the M.L. Annenberg School for Communication in his father's name at the University of Pennsylvania. Annenberg died in 2002 at the age of ninety-four.*

Living at the Science-Religion Interface

THEODOR BENFEY

IN THE PAST I USED TO SAY THAT RELIGION WAS LIKE SCIENCE—that religion dealt with knowledge that had to be found and checked in ways not too dissimilar from the ways in which the sciences develop. Now I would rather say that science is like religion—that we have pictured science falsely as almost an infallible path to knowledge, following definite rules; whereas, in fact, the great advances in both science and religion have been made by men and women who had sufficient powers of concentration and sufficient humility to open themselves completely to whatever was given to them in experience, and to live with what was given, to enter into it, until they sensed truths relating hitherto separate data of experience. Profound humility is required because the truths that may be sensed are almost invariably in fundamental opposition to many of the beliefs held by the person at the time.

In the field of science, Galileo, Newton, Einstein, Marie Curie, Harvey, Darwin are people of this stature; in the field of religion, the saints and prophets of the higher religions, and supremely in Jesus of Nazareth. To me,

Jesus was the supreme mystic, the supreme scientist, for he opened himself completely to truth. No shred of fear or personal ambition finally clouded his sight so that, in Tillich's phrase, "He made himself transparent to the forces of truth, to God, to reality, so that in Him I can see a reality incarnate, reality supremely revealed in a human person." And the glory of his revelation is that at bottom there is love, a love whose full nature was only seldom glimpsed: when we fall in love, when we hear of or experience a person's self-sacrifice for the sake of a friend, when we enter into the joy of a child.

I believe—though I seldom live up to it—that I live truly when I do not fear, that I find both reality and joy in losing myself in love. If love is reality, then it is love which binds me to other people and to God. Consequently, I am not the isolated individual the eye suggests, and spiritual growth is the growing awareness of the fact that I cannot plan my destiny, but that instead, I must progressively accept my membership within the community—or as Whitehead would put it, "the organism of men and God whose service is perfect freedom."

It is difficult for me in the rush of my daily existence to learn how to lose myself in love. Our religious heritage has cramped the emotions, and we must, I believe, rediscover the spiritual significance of beauty, of the arts, of drama, of dance, of the giving of man and woman to each other in love, as paths to the supreme giving of the self to God.

I have come to my present beliefs largely through the many men, women, and children who have made love a reality for me and through the writings and lives of the pioneers in science and in religion. As a scientist who claims an awareness of spiritual reality, the relation between scientific and religious knowledge remains an ever-pressing

problem, and the right use of science presents itself as a most urgent necessity of our time.

THEODOR BENFEY *was born in Berlin but moved to the United States, where he taught at three Quaker colleges: Haverford, Earlham, and Guilford. He became editor of* Chemistry *for the American Chemical Society and later was editor for the Chemical Heritage Foundation, was the translator of several science-related books, and developed a spiral periodic table. He married the artist and educator Rachel Thomas, with whom he had four children. Benfey now resides in Greensboro, North Carolina.*

The Proud People of a Proud Country

JAMES CAREY

PERHAPS MORE THAN ANYTHING ELSE IN THE WORLD, I BELIEVE in liberty: liberty for myself, liberty for my fellow men. I cannot forget the legend engraved on the base of the Statue of Liberty on Bedloe's Island in New York Harbor: *Give me your tired, your poor, your huddled masses yearning to breathe free, the wretched refuse of your teeming shore. Send these, the homeless, tempest-tost to me. I lift my lamp beside the golden door!* That is the voice of America.

As one small part of it, one tiny decibel in its sound, I, as a free individual of America, believe in it. It makes no boast of noble ancestry. On the contrary, it admits honestly that each of us in this country, with a possible and qualified exception of our native Indians, is a displaced person. In a particular kind of way, the Indian was our first displaced person. If you and I did not come from abroad ourselves, our forefathers did. The scourge that drove them was economic, political, or religious oppression.

Oppression has always strewn the shores of life with wretched human refuse. We who today are the proud people of a proud country are what might be called the reclaimed refuse of other lands. The fact that the flotsam and the jetsam, the persecuted and the pursued of all these other lands, the fact that they came here and, for the most part, successfully started life anew, this renews my faith in the resilience of a human individual and the dignity of man.

There are those who say we should be content with the material benefits we have accrued among ourselves. I cannot accept that for myself. A laboring man needs bread and butter, and cash to pay the rent. But he would be a poor individual, indeed, if he were not able to furnish the vestibule of his mind and his soul with spiritual embellishments beyond the price of a union contract.

I mean by this that I believe it is important for a man to discover, whether he is an electrical worker or an executive, that he is an individual with his own resources and a sense of the dignity of his own person and that of other men. We are separate. We are collective. Man can be strong alone but not indomitable, in isolation. He has to belong to something, to realize he is not created separately or apart from the rest of mankind, whether he is an American or a Mohammedan.

I am stirred by the abundance of the fields, the forest, the streams, and the natural resources they hold. But do these things make me important? Have we wrought the miracle of America because of these riches we hold? I say, no. Our strength—and I can say my strength, too, because I am a part of this whole—lies in a fundamental belief in the validity of human rights. And I believe that a man who holds these rights in proper esteem is greater, whether he is recognized or not.

As an individual, I must face the future with honesty and faith in the good things that have made us mighty. I must have confidence in myself, in others, and all men of goodwill everywhere, for freedom is the child of truth and confidence.

Called "Labor's Boy Wonder," JAMES B. CAREY *was still in his twenties when he was elected national secretary of the Congress of Industrial Organizations. By age forty, Carey founded and became the first president of the International Union of Electrical, Radio, and Machine Workers. President Truman appointed Carey to the President's Committee on Civil Rights in 1946. Carey died in 1973 at the age of sixty-two.*

The Rights—and Responsibilities—of Every Individual

Robert Arthur Evans

DOES IT REALLY MATTER WHAT ONE PERSON BELIEVES? I THINK it does. Just as I believe that every single individual can be a great influence for evil or for good in the community in which he lives. I firmly believe in the dignity of every individual, created to the image and likeness of his maker, and endowed by his creator with inherent sacred rights. But every individual who possesses these rights also has responsibility. He has duties. No man lives for himself. He has duties to himself, to his fellow men, and to his God. I believe that every individual must have self-respect if he would have others respect him. He must believe in himself; he must have confidence in himself if he would have others have confidence in him.

I believe in the basic equality of all men, regardless of their race, their creed, or their national origin. But I also believe that the same creator who made us equal endowed us with unequal talents. It is my conviction that, although not every American at this time practices the great American

creed of equality, the time will come when fair-minded citizens will take every man for what he is if he can prove to them that individually he is a person of genuine worth and worthy of respect.

As a youngster, I used to watch football teams line up and play the game. It was nothing more to me than one team winning and the other losing. Later on, when I became an actual participant, I saw that there was more to it all. There was competition of the right sort; there was skill and all the hard practice that made for skill; there was fellowship; and there was the will to win. There was the thrill of victory, the thrill of achievement, and I think that life is something like that when the game is played right.

No matter what a person's endowments may be, it is up to him to use his God-given talents to the very best of his ability. It is part of his responsibility to himself, to his fellow men, and to his maker. Anything that is worth *having* should be worth working for. And I thank God that I live in a country where anyone, regardless of his humble beginnings, can set his sights high and then work with all his might toward a worthwhile goal with all his strength and all his talents.

Over-reliance on self, however, is a dangerous thing when we have the notion that we are everything. I believe that religion should play a vital part in everyone's life. The recognition of one's maker and one's final judge must be part and parcel of life if it is to have any real and true meaning. And the Ten Commandments must be indispensable cornerstones in any building we might call success. We must work as if all depended on ourselves, even if we know in the last analysis, it all depends on God. This I believe. This I *firmly* believe.

ROBERT ARTHUR EVANS *was a North Philadelphia native and graduate of Roman Catholic High School. He was a three-year letter winner at the University of Pennsylvania, where he was the first African American captain of the football team. After graduating from Penn, he served four years in the navy, owned and operated a funeral home, and then worked as a banking executive. Evans died in 1996.*

The Evidence of Things Not Seen

Cyril G. Fox

WHAT I BELIEVE IS THE DISTILLATION OF LONG, SOMETIMES difficult years of experience in the act of living. The final essence rests upon a hard core of nature laws, anchored to and rising from faith. And what to me is faith? As expressed in Hebrews 11:1, it is "the substance of things hoped for, the evidence of things not seen."

I believe that intensively as man may probe, study, analyze, catalyze, and theorize, though he unlocks the secret of some certain natural phenomena, others tauntingly remain to defy him. Man, even man the scientist, therefore slips eventually and inevitably into the realms of hypothesis and speculation. And beyond that nebulous area, faith takes over, as indeed it must.

Astronomy, for example, is precise to the extent that the ageless movement of the celestial bodies through space may be timed and forecast to the split second. The chemical content of many stars, as well as their orbits and controlling force, are known. Through the new two-hundred-inch telescope on Mount Wilson, man sees worlds bigger than

ours, spinning through a limitless void. Yet whence come this endless, this staggering vastness?

Along with a specialist in astronomy, I am thrown back to a forced acceptance of this simple endpoint: "In the beginning, God created the heaven and the Earth, and the Earth was without form and void, and the darkness was upon the face of the deep. And the spirit of God moved upon the face of the waters, and God said, 'Let there be light.'" All that I believe, then, comes from a faith—a belief—that these things could not happen just by chance.

I do not understand or grasp the essential magnificence of the laws which created the universe. Yet I see their daily, their hourly workings. I press a light switch. What is electricity? I look at a flower. Can I arrange a pattern like that, reproduced truly and endlessly through generation? I examine the human eye and the act of seeing. Has man made any instruments so exquisite, so perfect?

I believe—I have faith—that man progresses, slowly, painfully, but surely. Since his first appearance on this spinning blob of mud he's come far, in a period measured in fleeting thousands of years against the Earth's recorded history of millions. I believe this, too, is part of a plan too intricate, too complex for me to understand, stupendous, inscrutable. Must I recoil then in deep frustration because in all things primordial I know not whence or how or why? Emphatically not, for I believe that as I work, think, live in humble reverence of a power transcending all in the midst of phenomena which are evidences of things not seen, I have firm, cogent reasons for my steadfast faith. After all, can there be a source of greater strength, comfort, and assurance in this changing world than such abiding faith? Surely our rock of ages.

CYRIL G. FOX *was the former president of the Fels Naptha Soap Company and former director of the Samuel S. Fels Fund. Fox and his wife owned Hildacy Farm, a fifty-five-acre plot of land that was originally part of a 1683 land grant from William Penn. Dedicated to environmental preservation, the couple vowed to preserve the land as a wildlife habitat. Fox died in 1969.*

My Mother's Words

PAUL COMLY FRENCH

IT IS STIMULATING AND HUMBLING TO TRY TO PUT INTO WORDS the faith by which we live. I suppose that with most of us, the private yardstick we apply to ourselves and our inner motives often stems from a fairly simple fact. I know that's true in my case. It comes from two things my mother said to me as a child and repeated many times over.

At the time, her statements made little sense to me, but over the years they've come to have more and more meaning. "Paul," she used to say, "you may be able to fool others, but you'll never be able to fool thyself." I'm a member of the Religious Society of Friends, and Friends believe there is an inner light, a part of God in every man. And I think that Mother was trying to make me understand that it was essential for me to follow the guidance of this inner light, this part of God that exists in each one of us, because failure to do so meant that I would not be living up to the best that I knew.

I think she tried to make me understand that men are easily fooled by a glib tongue and pretensions of grandeur but that I, myself, could never really face myself or be

satisfied unless I lived to the best that I knew. I think she tried to make me understand that at times it might be necessary, because of this inner urging, to do things and perform actions which might not be popular but which I would know were right.

And secondly, she used to say to me that it was important to take my job seriously but never myself. I think she was also trying to make me understand the saving value of a sense of humor in the difficult times that I would face as I grew older. I have thought of these statements of my mother's many times throughout my life, and I have come to see the wisdom that is hidden in them.

There is also, I think, a corollary to this philosophy: Human happiness comes from doing something that we believe is worthwhile and helpful to others. Human unhappiness, frankly, comes when we forget this very simple fact. I think that it is essential for our inner peace to feel that somehow, someway, we're helping to make the world a better place for our children. We get from life about what we put into it, and it seems to me as I grow older that we learn that happiness is within us and stems from the satisfaction we get from helping and sharing with our fellow man, of all races and creeds and nationalities.

I know little of theology and attach even less importance to it. Very often, it seems to me, theology only helps to confuse people about the simple faith that Jesus and the other great teachers and leaders have sought to give the world. A basic faith, at least to me, seems hard to find in the complexities of organized groups. But this simple faith of my mother's has given me a conviction and a guide, the life which I have tried—albeit not too effectively—to use as the basis of living and as the standard for the kinds of jobs I should try to do.

During the past seven years, I've had an opportunity, as the executive director of CARE, to visit more than sixty lands many times and to travel more than a million and a quarter miles. I have learned that human beings around the world are about the same in their desires and aspirations and that, by and large, they respond to the same stimulus of friendship and goodwill that we do here. More and more as I grow older, I am satisfied that the basic ideas—that "You'll never be able to fool thyself," and "Take thy job seriously but never thyself"—form a useful faith by which I can live.

PAUL COMLY FRENCH *was a reporter for the* Philadelphia Record *and* New York Post, *as well as a writer and state director of the Pennsylvania Unit of the WPA Federal Writers' Project. He was an activist and voice of conscientious objectors as the executive director of the National Service Board for Religious Objectors, and he was the executive director of the nonprofit organization CARE from 1947 to 1955. French died in 1960.*

Of Sonnets, Symphonies, and Socrates

Edith Hamilton

"I SEE IN SHAKESPEARE," THE POET KEATS SAID, "THE POWER OF resting in uncertainty without any irritable reaching after fact and reason." What Shakespeare knew, he could not prove by fact and reason. In the truth he was seeking there could not be certainty logically demonstrated or factually self-evident. There can never be that kind of certainty in the things that are greatest and most important to us. To me, in the course of my long life, this has become a profound conviction. No facts, no reasoning can prove to me that Beethoven's music is beautiful or that it is more blessed to give than to receive. No facts can prove to me that God is. There is an order of truth where we cannot have the proved certainties of the mind and where we do not need them.

The search for spiritual truth may be hampered by them, not helped. When people are certain they know, the way to more knowledge is closed. But to see beauty opens the way to a fuller perception of beauty. To love goodness creates more goodness. Spiritual certainty leads to greater certainty.

The truths of the spirit are proved not by reasoning about them or finding explanations of them but only by acting

upon them. Their life is dependent upon what we do about them. Mercy, gentleness, forgiveness, patience—if we do not show them, they will cease to be. Upon us depends the reality of God here on the earth today. "If we love one another God dwelleth in us." Lives are the proof of the reality of God.

When the world we are living in is storm-driven and the bad that happens and the worst that threatens press urgently upon us, there is a strong tendency to emphasize men's baseness or their impotent insignificance. Modern philosophy has turned that way; modern art, too. Is this the way the world is to go or not? It depends upon us.

St. John spoke of the true light that lighteth every man coming into the world. Belief in the indestructible power of that light makes it indestructible. This lifts up the life of every man to an overwhelming importance and dignity.

God leaves us free. We are free to choose Him or reject Him. No tremendous miracle will come down from heaven to compel us to accept as a fact a Being powerful enough to work it. What would that kind of belief do toward making love or compassion a reality? God puts the truth of Himself into our hands. We must carry the burden of the proof, for His truth can be proved in no other way. "Glorious is the venture," Socrates said.

EDITH HAMILTON *was a scholar, a writer, and one of the foremost interpreters of the classical civilizations of Greece and Rome. Educated at Bryn Mawr College, she later became headmistress of the Bryn Mawr School, a post she held for twenty-six years. Hamilton began her writing career at the age of sixty-two, publishing her first book,* The Greek Way, *which has become a classic. Hamilton died in 1963 at the age of ninety-five.*

The Heart of Life Itself

CHARLES E. HIRES JR.

FOUR YEARS AGO WHEN MRS. HIRES DIED, THE BOTTOM SEEMED to have dropped out of my little world. Our children were now grown men with their own problems and lives to live. We had been a very close family and greatly bound up in each other's welfare and happiness, and this love for each other seemed all that really mattered.

Continued interest in my business activities appeared so inconsequential and unimportant that I retired from active work after having put nearly forty years of my life in what I believed to be creative. For the following two years, most of my time was spent on my land, working with my hands, building houses, clearing land, and making roads. The nights seemed to pass more quickly when I was physically exhausted. Gradually I came to realize that I had cut myself off from the heart of life itself, human relations, and that as long as I lived, I had a duty to perform toward my fellow man. Surely there was some way I could give to others, something of value that I had gleaned from my sixty-two years of living. But just what had I learned and what did I believe? Well, this in part is what I do believe.

I believe each one of us is something more than our private selves and needs to develop interests beyond our small personal satisfactions. For there is little true satisfaction in exclusive possession of material things, as they are of value only if we have used our imagination to bring them into being for the good of others and so experienced achievement. I believe that satisfaction in living depends upon the worth of our living, for we either take from our fellow men or give of ourselves to them. I believe individual success can be measured only by what we have *done* for others, not what we have taken from them.

In looking back over my life, I feel that if I had only realized the truth in these beliefs when I was starting on my career, I would have been much more successful in the true sense of the word. And so, when Dr. Gilbert White, president of Haverford College, asked me if I would help with college students who were having difficulty in making up their minds as to what they were best fitted to do, I felt that it was a real opportunity to be of service. These young men welcomed the chance to discuss their problems, providing I do not lecture or offer advice, which would be presumptuous for me to give. But I do try to act as a sounding board for their thoughts in order to open up vistas as to what business or professional life can hold for them—providing they have some definite aim or goal which is in line with their beliefs and that offers something of value to others.

Many men are so frustrated through introspection and lack of assurance that they do not realize that the best way out is through action, action in taking a job that offers opportunity to put their creative talents to work, no matter how small they seem, and so gain faith in themselves and their ability to be useful members of the community.

To sum it all up, I believe that the answer to the age-old question, "Why are we here on Earth?" will only be found by breaking out of our own little world and using our creative talents to help our fellow man.

CHARLES E. HIRES JR. *worked his way up through his father's company and was president for thirty years of the Hires Root Beer manufacturing company. He was a Philadelphia native, a Quaker, and a graduate of Haverford College. He often stated that he had only loved two women in his life—his mother and his beloved wife, Ilse Keppelmann, with whom he had three sons. Hires never remarried and died in 1980 at the age of eighty-eight.*

The Hole in the Enemy's Armor

LEWIS M. HOSKINS

DURING THE HELTER-SKELTER DAYS OF GUERRILLA CIVIL FIGHTING in China, our Quaker unit found it hard to carry on the desperately needed medical work unobstructed. Appreciated by both sides, it still fell victim to the uncertainties of the tide of battle. For example, a Quaker hospital changed hands six times in ten days but carried on its medical work throughout. The necessity of identification by both armies made necessary occasional trips across no-man's land. In such cases, if it was somewhat ticklish leaving one side, it was more difficult to make contact with the army of the other side.

I remember one such trip to negotiate with Communist authorities regarding the medical needs of this fought-over area. We were well into disputed territory when a Chinese member of the unit and I were captured by a lone Communist sentry. He was only a youngster of perhaps fourteen and was dangerous primarily because he was badly frightened. I was acutely conscious of the barriers which divided us. In addition to the normal ones of nationality, race, and language were the unnatural ones of fear, suspicion, and

hatred produced by propaganda. I was a representative of the nation he had been told was the enemy of his people. Though unarmed, I was suspected of trickery and deceit.

After considerable palaver, the young Communist soldier agreed to permit my Chinese colleague to return for the other members of our negotiating party while I would be held hostage. For over twenty minutes as I faced this intense Chinese lad, covering me with his rifle, I tried to win his confidence through the persuasion of open-heartedness. I hoped to penetrate to his better nature through the power of friendship. As I talked haltingly with him in Chinese about everyday things, reassuring him of my goodwill and desire to help his people, I fell upon a device to reach through the artificial barriers and touch his human and normal side. I showed him a picture of my young daughter and then asked him about his own family. He told me of a baby sister at home and an older brother also in the army. Unconsciously, it seemed, he put down his gun. In my halting Chinese I told him about the work of the Quaker unit, why we were there, and how we hoped to bring friendship and goodwill with our technical assistance.

No matter how encrusted had become his suspicion and hatred, long built up by propaganda, it was possible to reach through to his common humanity and to elicit a friendly response from his deeper spirit. When the rest of the Quaker party had arrived, the young soldier agreed to pilot us back to his headquarters, where we could carry out our vital negotiations.

I cite this personal incident to illustrate my faith in the possibility, under God, of that vital deeper communication among all members of our common humanity, which is necessary for peace and understanding.

LEWIS M. HOSKINS *led a life of service guided by his Quaker beliefs. He volunteered for three years with the nonpartisan Friends Ambulance Unit in China, which provided medical and humanitarian aid. Lewis also worked for nine years as executive secretary of the American Friends Service Committee in Philadelphia, and in 1947, he was among the members of the delegation sent to receive the Nobel Peace Prize on behalf of the AFSC. Hoskins died in 2011. He was ninety-four.*

A Brighter Tomorrow

WILLIAM HUBBEN

IT HAS BECOME SOMEWHAT FASHIONABLE TO BE CYNICAL ABOUT human progress, and one can hear voices telling us that we have been too lavish or hasty in our praise of human progress. It is true that two wars have occurred within one generation, that the danger of a third world war is looming large, and that the mass movements of fascism and communism are signs of man's immaturity. While we cannot ignore such arguments, they point to symptoms rather than the actual causes of a diseased human society.

I believe we are on the road to progress. Wars and social revolutions have always pointed toward unresolved human tensions which should and could have been removed at a much earlier time if we had been alert enough to recognize them.

I have received most of my training in the German school system, and in retrospect, I realize now that the absence of a friendly understanding and humane treatment of children and young people in the German educational system of old was bound to produce the brutalities and explosions we have witnessed in our time. The complete absence of democratic

principles in Russian public life has had results that were even worse. Lack of understanding and tenderness will always take a frightful toll in human happiness.

I believe that a generation of young people is growing up and has a greater capacity for understanding the past and present than former generations may have had. Our young people are witnessing moral confusion in the private lives of many men and women, but they also see the quiet and normal ways in which most of our citizens go about their duties. They know of some corruption in politics, but they also know of the moral resistance of responsible men and women in all walks of life who demand decent standards of our public officials.

Young people of today have a keen sense for moral values, and their increasing participation in religious and humanitarian activities is proof of their sense of obligation toward society.

The questions that seem nowadays uppermost in the minds of young and old are: When will the present sense of suspense and tension cease bothering us? When will life begin? I'm afraid the answer will have to be that life just isn't meant to be that easy. The higher rewards of living and of moral effort are the result of worry, care, and concern for our fellow man and a part of human dignity. Mankind is one and indivisible. And starvation, suffering, and suppression in one part of the world cannot and must not leave other nations untouched.

Suffering at home can only be alleviated or removed by those who adhere to their sense of duty and who practice in a steady and silent manner what the best intimations of their hearts tell them. The great danger in our time is that we misjudge our individual, national, and international problems by not recognizing that they point toward tensions

to be resolved patiently and with faith in man's destiny. Life has meaning, dignity, and joy in spite of the many besetting problems of our days. If we ask for it, we shall receive inspiration and vision from within to create more sunshine, warmth, and light in the world of tomorrow.

WILLIAM HUBBEN *was a prominent Quaker educator, speaker, editor, and author of books and articles in the fields of religion and literature. Born in Germany, Hubben immigrated to the United States in the mid-1930s. He became the editor and manager of* Friends Intelligencer *in 1943 and remained as editor of its successor,* Friends Journal, *until 1963 and as contributing editor until his death in 1974. He also taught from 1963 to 1973 at the William Penn Charter School in Philadelphia.*

The Soundest Investment of All

C. Jared Ingersoll

I feel very presumptuous and uncomfortable about trying to explain out loud the things I believe in. But I do think that all human problems are in some way related to each other, so perhaps if people compare their experiences they may discover something in common in hunting the answers.

I am a very fortunate man for I lead a full and what is for me a happy life. I say this even though I happen to have had, in the course of it, a couple of severe personal blows. My first wife collapsed and died one day while she and I were ice skating, after eighteen years of a most happy existence together. My only son, a sergeant in the army combat engineers, was killed in Italy in the last war. Nevertheless, these tragedies did not throw me completely, and I have been able to fill my life anew with happiness.

I do not mean to sound calloused. Those blows hurt me deeply. I guess that two basically important things helped me most to recover. One is the fact that I have come to see life as a gamble. The other is a belief in what some people call the hereafter. I try to live fully so that when

and if my luck changes there will be little room for regret or recrimination over time lost or misspent. My belief in the hereafter is wrapped in the intangible but stubborn thoughts of a layman. Very likely I would get lost in trying to describe or defend, by cold logic, my belief in God, but nobody could argue me out of it.

I have come to believe that I owe life as much as it owes me, and I suppose that explains this fine satisfaction I get out of endeavoring to do a job to the best of what ability I have and out of helping somebody else.

As a kid, I used to ride a rake in the hayfields. I got a tremendous kick out of trying to sweep every field clean as a whistle. Here I made a surprising and happy discovery— that there could be actual enjoyment in the exercise of thoroughness and responsibility, and that duty didn't have to be a drudge.

I don't know exactly why, but I like to do things for other people. Not only family responsibilities, work on a hospital board, and various church organizations but also the most inconsequential things that might hardly seem worth the time. My office happens to be on Independence Square, and now and then I have occasion to direct a tourist to the Liberty Bell or fill him in on a little of the history of Philadelphia. The tourist doesn't seem to mind, and it makes me feel good. I'm afraid I'm not very profound. I have tried to comprehend why something so simple and so sound as the Golden Rule is so often forgotten or held in disrepute. I can only say—and I say this quite selfishly—that I have found it a good investment. It has paid me a very high return, undoubtedly more than I deserve.

C. JARED INGERSOLL *was a Philadelphia railroad magnate and banker who worked as a civilian during World War II, advising army colonels and directing the purchase of millions of dollars worth of equipment. He was a recipient of the Medal of Merit from President Harry S. Truman and of the Army Certificate of Appreciation from President Eisenhower. Ingersoll was also at the forefront of major civic issues in Philadelphia. He died in 1988 at the age of ninety-four.*

The World Is a Brotherhood

BETTY MUTHER JACOB

MY HUSBAND AND I HAVE TWO BOYS IN GRADE SCHOOL AND A daughter in junior high. I keep asking myself over and over again, how can we help them learn to believe in themselves and in the future when every day the world seems to be threatening to blow itself up? Some of my beliefs, the most dramatic ones I suppose, have broken under the strain of reality. Others have held and are actually stronger from the test of experience.

Like nearly everybody else, I learned that golden text, "love thy neighbor as myself," when I was a little girl. It was a pretty phrase, but the words didn't really say anything to me for a long, long time. Then suddenly, they seemed to be the answer to everything. The world is a brotherhood.

Just out of college, I went abroad in a rosy flush of goodwill to meet my foreign brothers and sisters, so to speak, to work with them for a new world. A great vitality seized me and made everything seem possible.

Then came the awakening. The idea, like a cut flower, didn't stay fresh. It faded and died in the doubletalk of dictators

and ordinary politicians and the conniving suspicions of governments. I complained to a friend that if this idea was the truth, why didn't it flourish? And I remember his answer: "How do you know truth won't triumph? None of us knows," he went on, "when the seeds we sow will sprout or where. Some will be destroyed. But if you'll recognize the truth in your heart and try to live the consequences of that truth in your life, the positive effort itself will give your life meaning."

Each life that testifies to a truth in itself is fulfilling a part of the truth. Faith without action is meaningless, but action must be based on faith. My friend taught me that truth cannot win overnight, but it's worth living for.

In recent years as a representative of the United Nations, I have traveled through most of the Communist countries of Europe. I talked to farmers and workers, government clerks and doctors, housewives and chauffeurs, all kinds of people. Underneath, their concerns were the same as mine—peace and a future for their children. If I couldn't pronounce their names or accept their dialectic, I could read the simple hopes and fears in their faces, and I felt a kinship with them as human beings.

And I asked myself, if men like Jesus and Mohammad and Gandhi were all impractical dreamers when they taught that men were brothers, what is the practical alternative?

I realized, with the clarity of shock, that there is no practical alternative. The brotherhood, the unity of man, is not a dream, not if the desires and hopes of ordinary men are recognized. It seems to me that the hope of our very survival lies in teaching ourselves to understand and accept the fact that we are indeed our brother's keeper.

The best, the only valid answer that I can think of to give my children is to show them as best I can in the lives we lead every day that all men belong to each other.

BETTY MUTHER JACOB *held a variety of positions at the University of Pennsylvania, including administrator of International Studies of Values in Politics. She served as the assistant to executive directors of UNRRA from 1945 to 1946 and of UNICEF from 1947 to 1954. She later helped found the University of Hawaii's Matsunaga Institute for Peace, where she was known as the "Godmother of Peace Studies." Jacob died in 1999 at the age of eighty-nine.*

The Value of Disappointment

JOHN B. KELLY SR.

BACK IN 1920, I WAS ALL SET TO GO TO ENGLAND TO COMPETE in the Diamond Sculls race. I had won all the major sculling titles in the United States, and to me, a chance to compete in the Diamond had become the most important thing in my life. For years, I had been pointing for it. Then on the dock, just a few hours before I was to sail, I received a cable. It said I had been disqualified. The reason, while never officially announced, was because I had served an apprenticeship as a bricklayer, and the stewards felt that a man who worked with his hands had an advantage over a gentleman. This was the bitterest disappointment I have ever had. Nothing would console me then. "Whatever is, is best," my father said. But I refused to believe it.

It happened that the Olympic games were to be held in Antwerp that same year, and although the United States had never before sent crews to compete in the rowing events, it was announced one day that Olympic trials would be held for American entries at Worcester, Massachusetts. Here was new hope. I could win the trials, represent the United States

at Antwerp, and, with luck, meet a lad named Beresford, who had won the Diamond, for which I had been denied the right to compete. He would be England's Olympic entry. Here was a chance to get even.

I won at Worcester and sailed for Belgium a few days later. What I wanted most of all was to meet Beresford in the finals. I guess it was presumptuous, but I mentioned the matter to God. I have always said prayers every night and every morning. I make it a kind of talk with Him. Well, this time I laid out my plan very carefully. I explained that if He would have Beresford's name drawn in the opposite bracket to mine—and we both won all our heats—then we must meet in the final. In view of the ten years' work I had put into preparation for the Diamond, only to have my entry rejected, I didn't think I was asking too much if He would arrange the draw. The rest would be up to me.

That was how it turned out. Beresford was drawn in the upper bracket, and I was in the lower one. We moved steadily toward each other through the eliminations. I remember well the night before the championship. In the semifinal, I had beaten Hatfield of New Zealand, the favorite for the title, and Beresford had beaten Eichen of Holland. When I went to bed, the stars were shining brightly through the open window. "Thank you, God," I said. "You won't hear another word from me. You have done your part. It's up to me tomorrow."

I beat Beresford the next day, and the victory was sweeter than if I had won the Diamond alone. Looking back today, I don't mean to suggest that God, Himself, interceded in that draw. But I believe that life has a mysterious way of balancing the books. Success and prosperity can sometimes hurt a person more than adversity. Without that first abysmal disappointment, I might never have won. Beethoven once

said, when he lay near death, that of all the experience he had in his career, if he had to give up all the memories but one, he would keep his disappointments because they taught him most. This, I really believe.

JOHN BRENDAN "JACK" KELLY SR. *was one of the most accomplished American rowers in the history of the sport of rowing. One of the most well-known athletes of his generation, Kelly was the first person to win three Olympic Gold Medals in the sport of rowing. He was the father of Grace Kelly, actress and princess of Monaco, and of John B. Kelly Jr., who was also an accomplished rower.*

Freedom and Justice for All

Louis E. Levinthal

As a boy, the words "freedom" and "justice" were hammered into my mind. My parents, immigrant pious Jews, had fled Russia in search of freedom and justice. And they were determined that I should know their values. At the Horace Binney School in Philadelphia, my teacher took our class regularly to visit Independence Hall. I learned with pride that the inscription on the bell proclaiming liberty throughout all the land came from the Hebrew Bible. But as I grew older, I began to question the validity of freedom and justice. I had accepted these concepts because I was told to; but did they really work?

I have seen miscarriages of justice that bear shameful witness to the weakness and prejudices of men. And yet, as I think of it now, I have seen far, far more just trials than unjust ones; I have seen far, far more human beings respond, when they had a chance, to decency and fairness than to evil and the breaking of a trust.

I remember the case of an eighteen-year-old boy I once sentenced for burglary. It was his third offense, and after

the youngster had pleaded guilty, the prosecutor said to me, "Judge, I'm afraid the only thing to do now is to put him away in jail. He's broken probation twice before." But there was something about his looks that made me feel we didn't have all the evidence. We investigated. His home life was a nightmare, and interestingly enough, each one of the boy's thefts had been committed immediately after a violent fight between his mother and father. I suppose a psychologist would call it his way of showing revenge.

I couldn't see where prison would do him any good. I put him on probation, providing he joined the army. He seemed curiously grateful. The next I heard of him, months later, he was a bombardier in the air force. His mother sent me a message saying he had been shot down and captured by the Germans and had won a Presidential Citation for bravery. She added, incidentally, that she and her husband were reconciled. Released from prison camp after the war, the boy showed up in my chambers one day with his fiancée. He wanted me to marry them; I did. He was pardoned for all his crimes, and today he is making good on a job in a Pennsylvania factory.

This was an unusual case. Yet not once, but many times, I have seen even so-called hardened criminals acquire a sense of dignity when given a chance to live in freedom in an ordered, democratic society. A professor I know recently confessed he was discouraged about life. He said, "When the Lord made man, he put in a little too much hog and a little too much tiger." But I don't believe the Lord is responsible for our hoggishness or our ferocity. These are man-made corruptions of the human spirit with which God endowed us all. I believe that man has the capacity for self-improvement, for the elimination of his defects, and for the development of the divine spark in his soul.

I believe we can best expand our capacities in a society framed in freedom and justice, where each citizen is called upon to contribute to the common welfare and where all the uniquely different personalities are harmonized toward the common good. When I have my doubts, I think of the case of the burglar who became a bombardier, and I am reassured.

The Honorable LOUIS E. LEVINTHAL *was a University of Pennsylvania graduate admitted to the Pennsylvania bar in 1916. He was a lecturer on bankruptcy and corporate reorganization at the UPenn Law School from 1933 to 1937. He then served as common pleas judge until 1959. Levinthal died in 1976. He was eighty-four.*

The Vital Human Difference

RICHARD H. MCFEELY

I HAVE ALWAYS LOVED SPORTS. IN HIGH SCHOOL AND COLLEGE I played almost everything—football, basketball, baseball, lacrosse, and all the rest. I had planned graduate study in physical education and then working in it with young people. Suddenly, during the football season in my senior year in college, I was stricken with infantile paralysis. I was told I had lost the use of my legs forever except with crutches or braces.

Two of the most valuable lessons of my life grew out of this crippling attack. At first I was very low in mind and spirit. I had no real hope for the future. One day my mother revealed to me the two lessons which have helped me immeasurably ever since. She realized, as only a mother can, the depths of my mental depression. She wanted to help me by giving me something that would sustain me, strengthen a waning courage, revitalize a spirit of self-forgetfulness.

"Dick," she said, "what life does to you in the long run will depend on what life finds in you. You know we can change any situation by changing our own attitude toward it." She

went on to point out that we could not always explain our hard luck, which so often seemed unjust and undeserved.

"Remember," she added, "it is not so much what life brings to us in her hands as what we bring to life in our spirits—this makes the real difference between persons."

The other point Mother developed for me was this: "No one ever finds life worth living. One always has to make it worth living. Look at all the men and women who have lived successful, creative lives—in whatever period of history. They have not always been the prosperous, the fortunate, sitting on the cushioned seats. Look at Jesus— poor, homeless, misunderstood, crucified. Beethoven," she went on, "created some of his greatest music after he was deaf. Helen Keller and other moderns have also risen above life's adversities and misfortunes. They did so in spite of such circumstances and because of the courageous spirit within them."

Remembering this advice in the intervening years, I have asked myself, "Is life worth living?" and I have found the answer in the attitudes we hold and the quality of our spirit, not outward circumstances. Birth and death, happiness and sorrow, illness and good health, love and loss—these I find are no respecters of persons. They come alike to all. But not all respond alike. Some go to pieces, dissolve in self-pity, become a burden to others, perhaps even take their own lives in their despair and hopelessness. Others have something in them that in spite of ill fortune enables them to live constructively and creatively. Ofttimes it is more difficult to live a happy, useful life when all the breaks seem to be good ones.

For the most part, I think that what all things do to us will depend on what they find in us. "Life does not consist in holding a good hand, but in playing a bad hand well."

Together with these thoughts inspired by my mother in a dark hour of my life, I have long found help and inspiration in this prayer by Charles Lewis Slattery:

> *Almighty God, we thank thee for the job of this day: may we find gladness in all its toil and difficulty, in its pleasure and success, and even in its failure and sorrow. We would look always away from ourselves, and behold the glory and the need of the world that we may have the will and the strength to bring the gift of gladness to others; that with them we may stand to bear the burden and heat of the day and offer thee the praise of work well done. Amen.*

RICHARD H. MCFEELY *was an educator, widely known author, and lecturer on social and religious problems. McFeely contracted polio while in college at Swarthmore and then spent time at a rehabilitation center in Georgia, where he met Franklin D. Roosevelt. After finishing his rehabilitation therapy in 1929, McFeely returned to Swarthmore as assistant dean. He joined the George School as head of school two years later. McFeely died in 1966.*

A New Control of Destiny

MARGARET MEAD

CHILDREN USED TO PLAY A GAME OF POINTING AT SOMEONE, suddenly saying, "What are you?" Some people answered by saying, "I am a human being," or by nationality, or by religion. When this question was put to me by a new generation of children, I answered, "An anthropologist." Anthropology is the study of whole ways of life, to which one must be completely committed, all the time. So that when I speak of what I believe as a person, I cannot separate this from what I believe as an anthropologist.

I believe that to understand human beings it is necessary to think of them as part of the whole living world. Our essential humanity depends not only on the complex biological structure which has been developed through the ages from very simple beginnings but also upon the great social inventions which have been made by human beings, perpetuated by human beings, and in turn give human beings their stature as builders, thinkers, statesmen, artists, seers, and prophets.

I believe that each of these great inventions—language, the family, the use of tools, government, science, art, and philosophy—has the quality of so combining the potentialities of every human temperament that each can be learned and perpetuated by any group of human beings, regardless of race, and regardless of the type of civilization within which their progenitors lived, so that a newborn infant from the most primitive tribe in New Guinea is as intrinsically capable of graduation from Harvard, or writing a sonnet, or inventing a new form of radar as an infant born on Beacon Hill.

But I believe, also, that once a child has been reared in New Guinea or Boston or Leningrad or Tibet, he embodies the culture within which he is reared, and differs from those who are reared elsewhere so deeply, that only by understanding these differences can we reach an awareness which will give us a new control over our human destiny.

I believe that human nature is neither intrinsically good nor intrinsically evil, but individuals are born with different combinations of innate potentialities, and that it will depend upon how they are reared—to trust and love and experiment and create, or to fear and hate and conform—what kind of human beings they can become. I believe that we have not even begun to tap human potentialities, and that by continuing humble but persistent study of human behavior, we can learn consciously to create civilizations within which an increasing proportion of human beings will realize more of what they have it in them to be.

I believe that human life is given meaning through the relationship which the individual's conscious goals have to the civilization, period, and country within which one lives. At times, the task may be to fence a wilderness, to bridge a river, or rear sons to perpetuate a young colony. Today, it

means taking upon ourselves the task of creating one world in such a way that we both keep the future safe and leave the future free.

> *Anthropologist, author, lecturer, and social critic* MARGARET MEAD *spent many years in Polynesia studying native cultures. She also worked as an associate curator at the American Museum of Natural History, professor at Columbia University, and president of the American Association for the Advancement of Science. Mead died in 1978.*

All Men Are My Brothers

James Michener

I BELIEVE THAT ALL MEN ARE BROTHERS. I REALLY BELIEVE THAT every man on this earth is my brother. He has a soul like mine, the ability to understand friendship, the capacity to create beauty. In all the continents of this world I have met such men. In the most savage jungles of New Guinea I have met my brother, and in Tokyo I have seen him clearly walking before me.

In my brother's house I have lived without fear. Once in the wildest part of Guadalcanal I had to spend some days with men who still lived and thought in the old stone age, but we got along together fine. In the South Pacific, on remote islands, I have sailed and fished with brown men who were in every respect the same as I.

Around the world I have lived with my brothers, and nothing has kept me from knowing men like myself wherever I went. Language has been no barrier, for once in India I lived for several days with villagers who didn't know a word of English. I can't remember exactly how we got along, but the fact that I couldn't speak their language

was no hindrance. Differences in social custom never kept me from getting to know and like savage Melanesians in the New Hebrides. They ate roast dog and I ate Army Spam, and if we had wanted to emphasize differences, I am sure each of us could have concluded the other was nuts. But we stressed similarities, and as long as I could snatch a navy blanket for them now and then, we had a fine old time with no words spoken.

It was in these islands that I met a beat-up, shameless old Tonkinese woman. She would buy or sell anything, and in time we became fast friends. I used to sit with her, knowing not a word of her curious language, and we talked for hours. She knew only half a dozen of the vilest English obscenities, but she had the most extraordinary love of human beings and the most infectious sense of this world's crazy comedy. She was of my blood, and I wish I could see her now.

I believe it was only fortunate experience that enabled me to travel among my brothers and to live with them. Therefore I do not believe it is my duty to preach to other people and insist that they also accept all men as their true and immediate brothers. These things come slow. Sometimes it takes lucky breaks to open our eyes. For example, if I had never known this wonderful old Tonkinese woman I might not now think of all Chinese as my brothers. I had to learn, as I believe the world will one day learn. Until such time as experience proves to all of us the essential brotherhood of man, I am not going to preach or scream or rant. But if I am tolerant of other men's prejudices, I must insist that they be tolerant of me. To my home in rural Pennsylvania come brown men and yellow men and black men from around the world. In their countries I lived and ate with them. In my country they shall live and eat with me. Until the day I die, my home must be free to receive these travelers, and it never

seems so big a home or so much a place of love as when some man from India or Japan or Mexico or Tahiti or Fiji shares it with me. For on those happy days it reminds me of the wonderful affection I have known throughout the world.

I believe that all men are my brothers. I know it when I see them sharing my home.

> JAMES MICHENER *was a popular author of numerous bestsellers, including his Pulitzer Prize—winning novel,* Tales of the South Pacific, *inspired by his travels during his naval service in World War II. Many of his subsequent novels, including* Hawaii *and* Centennial, *were based on detailed historical, cultural, and geological research. Michener's literary career spanned fifty years and forty books. He died in 1997.*

A Potential of Decency

Herbert E. Millen

I FIND THAT A COURTROOM IS A PLACE WHICH CONSTANTLY TAXES one's beliefs in life and humanity: The boy who robbed a service station knew it was wrong, but he did it anyway. The mother who abandoned her children in a cold flat while she went to a dance was sorry, but she would probably do it again. The list is endless, the misdeeds and misfortunes crowded into a court calendar often seem to make a mockery of the things we have been taught to regard as virtuous and good. Nevertheless, I am something of an optimist. I still believe that man is basically a positive creature capable of great things beyond himself.

It is ironic, perhaps, but it usually takes a disaster to bring out the best in people. Invariably in a flood or famine or in the midst of war, we become a little more human, a little more brotherly toward our immediate neighbors. That proves, I think, that a potential of decency exists in us, but the constant strain of living can easily obscure that potential.

People are fallible and weak. When I was a boy, I remember there was a rocking chair in our house I kept tripping over. Every time, I would turn around and give it a vicious kick. Once, after I had nearly broken my foot, I realized that I wasn't hurting anybody but myself. I think it is important to discover and admit one's own imperfections; then it is easier to understand and endure them in somebody else.

Inevitably, I am sensitive to prejudice. I appreciate, now, that prejudice is a childish thing, as senseless a reaction as kicking a chair, but it does exist. It is a cause of artificial differences which separate people. However, these differences are worn down as people come to know each other. Strangers thrown together come to know themselves for what they are, not for what they thought they were. It has been my observation that no matter who they are or where they come from or what they look like, people do respond to kindness and understanding. Therein lies my belief— that an operable brotherhood of humans, while still a long way off, can be achieved if we can train ourselves to think and act first of all as human beings, not just as members of a certain group, race, creed, or even nationality.

There is no use denying that I sometimes become impatient and discouraged at the slowness of progress along these lines. When I do, I am frank to say that I find support in my religious beliefs. There is too much lip service being given to Christian ideals these days, and that applies both inside church and out. But I have yet to find a sounder code of ethics and behavior than the Sermon on the Mount or a more reassuring message than the Twenty-third Psalm. When I come across a familiar passage in the Bible, it is like getting a letter from my mother when I am away in a strange place. It is a friendly and recognizable message, and it makes me feel calm and warm. I cannot analyze all the reasons

for this, but that does not bother me. The experience of comfort is no less real, and I need it in order to face the harshness of reality.

In 1947, Honorable HERBERT E. MILLEN *became the first African American judge appointed to the Philadelphia Municipal Court in Pennsylvania, and he was the thirteenth black judge appointed in the United States. Millen served for a decade as president of the Board of Directors at Mercy-Douglass Hospital. He died in 1959.*

How to Refill an Empty Life

ALBERT J. NESBITT

ONE DAY ABOUT FIFTEEN YEARS AGO, I SUDDENLY CAME FACE
to face with myself and realized there was something quite
empty about my life. My friends and associates perhaps
didn't see it. By the generally accepted standards, I was
"successful," I was head of a prosperous manufacturing
concern, and led what is usually referred to as an "active"
life, both socially and in business. But it didn't seem to me
to be adding up to anything. I was going around in circles.
I worked hard, played hard, and pretty soon I discovered I
was hitting the highballs harder than I needed. I wasn't a
candidate for Alcoholics Anonymous, but to be honest with
myself I had to admit I was drinking more than was good for
me. It may have been out of sheer boredom.

I began to wonder what to do. It occurred to me that I
might have gotten myself too tightly wrapped up in my job,
to the sacrifice of the basic but non-materialistic values of
life. It struck me abruptly that I was being quite selfish, that
my major interest in people was in what they meant to me,
what they represented as business contacts or employees,

not what I might mean to them. I remembered that as my mother sent me to Sunday school as a boy and encouraged me to sing in the church choir, she used to tell me that the value of what she called a good Christian background was in having something to tie to. I put in a little thought recalling the Golden Rule and some of the other first principles of Christianity. I began to get interested in YMCA work.

It happened that just at this time we were having some bitter fights with the union at our plant. Then one day it occurred to me: What really is their point of view, and why? I began to see a basis for their suspicions, their often chip-on-shoulder point of view, and I determined to do something about it.

We endeavored to apply—literally apply—Christian principles to our dealing with employees, to practice, for example, something of the Golden Rule. The men's response, once they were convinced we were sincere, was remarkable. The effort has paid for its pains, and I don't mean in dollars. I mean in dividends of human dignity, of a man's pride in his job and in the company, knowing that he is no longer just a cog but a live personal part of it and that it doesn't matter whether he belongs to a certain church or whether the pigmentation of his skin is light or dark.

But I can speak with most authority on how this change of attitude affected me and my personal outlook on life. Perhaps, again, many of my friends did not notice the difference.

But I noticed it. That feeling of emptiness, into which I was pouring cocktails out of boredom, was filling up instead with a purpose: to live a full life with an awareness and appreciation of other people. I do not pretend for a second that I have suddenly become a paragon. My faults are still legion, and I know them.

But it seems to me better to have a little religion and practice it than think piously and do nothing about it. I feel better adjusted, more mature than I ever have in my life before. I have no fear. I say this not boastfully but in all humility. The actual application of Christian principles has changed my life.

ALBERT J. NESBITT *was president of the John J. Nesbitt Company, which manufactured heating and ventilating units. Among his many civic activities, Nesbitt served as the president of the Philadelphia YMCA and the Philadelphia Council of Churches. He was a member of Drexel University's Board of Trustees from 1953 to 1970, serving as chairman of the board from 1966 to 1968. He died in 1977.*

Making Room for the Spiritual Side of Life

CLARENCE E. PICKETT

WHAT DO I BELIEVE? LET ME TELL YOU A LITTLE STORY. IT HAPPENED in the closing days of 1950. Just as General MacArthur announced the imminent end of the Korean War came the invasion by Chinese troops. A delegation from Peiping arrived on the scene at Lake Success, where I had been spending most of my time watching United Nations proceedings. The western powers wished to debate peace in Korea; the Chinese insisted on debating what they called "American aggression in Formosa," and both sides were adamant.

Midnight, December 1, one of my Quaker colleagues lay awake wondering what could be done to ease the pressure. Her mind wandered back to another heated conference in London, between India and the British government, when independence weighed in the balance. Then a little Quaker meetinghouse had been made available to all conferees for meditation. Gandhi and others used it. Couldn't something of that sort be done on the Korean question? Might it not be already the time to inaugurate a little meditation chamber at Lake Success?

We asked the secretariat. The response was hearty and immediate. But would any considerable number of countries support such a step? My colleagues and I, who had no official UN responsibility of any kind, interviewed a number of delegates.

I shall never forget the experience of talking with British, American, Indian, Pakistan, Canadian, Lebanese, and other representatives. All, with a sense of relief and in a climate of hope, warmly encouraged the move. It was as if a new force had entered to lighten the load. Now the meditation chamber is in use. Great issues still stagger the minds and spirits of men. But almost any time one passes the little chamber now, one sees some harried delegate in meditation or prayer.

There was no room at the inn, and Jesus was born in a stable. Perhaps it is significant that although space at Lake Success is at a great premium, room was found to symbolize the life of the spirit in a world of political tension, where men with heavy hearts and puzzled minds can pause for inspiration, courage, and insight.

As beautiful as it is, many people believe that the story of Christ's birth has very little application in a world which depends on positions of strength for its security. But here in the quite unspiritual atmosphere of the UN was proof that there is a quality of spirit in men that can change the very climate in which they live and alter their standard of values and make them act differently toward each other. Then the life of the spirit begins to assume a practical quality which so often eludes us.

Seeing the way in which this tangible testimony to the reality of the spiritual side of men's lives comes into being confirms my conviction that men of all kinds, of all colors, and under all circumstances have something that can be

appealed to, that can be touched, and that can transform their relations with their fellows. Gandhi once said that he didn't expect to change his enemies' attitudes by constantly reminding them of their worst evils. I think Gandhi was right, and believing this, I shall do what I can to work for a response to the divine within the texture of the daily living among men and nations.

CLARENCE E. PICKETT *was a Quaker humanitarian who dedicated his life to peace. From 1929 to 1950, he was executive secretary of the American Friends Service Committee, which won the 1947 Nobel Peace Prize. He was prominently involved in peace education, the furtherance of equality, refugee and relief work, and diplomacy between the United States and the Soviets, with a close working relationship with Eleanor Roosevelt. Pickett died in 1965.*

To Love God and Man with Our Whole Hearts

DAVID RICHIE

WHEN I WAS IN COLLEGE MORE THAN TWENTY YEARS AGO AT A TIME of great personal uncertainty and despair, a friend made a proposal I can never be too grateful for. He suggested that I live for a week just as I please, just as if nobody else mattered, as if the purpose of life was personal, selfish pleasure. After that, he suggested that I turn around and live the second week as I would live if I knew all men were created by a loving father whose purpose was that we should all love one another.

By the end of the first week, I had made every associate either disgusted or mad at me and made myself miserably unhappy. When I suddenly changed into a friendly, generous, cooperative person trying to go out of my way to promote the happiness of those around me, the effect upon myself and my companions was convincingly dramatic. From that time on, I have never had any doubt about the wisdom of trying to devote my life to the welfare of others. I have gone from one adventure in goodwill to another, and as a result, I have been one of the most consistently happy persons I have known.

It has been my privilege to participate in summer international, interfaith, and interracial work camps in a dozen states of the United States and nearly a dozen countries of Europe. For ten winters, I have organized and led more than three hundred weekend work camps in the slums of Philadelphia. Twelve or fifteen volunteers join me in making camp in a settlement house in a blighted area. From there, on Saturday, we scatter out in teams of two to needy homes, where we pitch in with the tenants to paint and plaster and do whatever else is needed in fixing up.

What has been the result? The major result has been to convince me beyond a shadow of a doubt of the eternal rightness of the Commandments of both Old and New Testament, to love God and man with our whole hearts. We can deny the rightness of these Commandments, as many Russians are doing. We can preach them but fail to practice them, as many Americans are doing. Either way, I think, the inevitable result is increasing tragedy. What holds for individuals holds for nations because nations are people. Therefore, I must believe that unless we as a nation choose to share life's good things as wholeheartedly as we are willing to prepare for war, much of the world will turn against us, just as my associates turned against me during that first experimental week in college.

A second result of these projects has been to convince me that men really are brothers. In intimacy of camp, I found our Finnish and German volunteers were very much the same as our Negro and white American campers. Different religions or bank accounts didn't matter. We all needed essentially the same things, we all wanted essentially the same things; we all were happiest when we forgot ourselves and helped each other.

A third result has been to prove that demonstrations of sincere goodwill strengthen the good in others. They do

become more socially responsible. Whether Polish peasant or Philadelphia slum dweller, they respond to genuinely friendly action in a way that no amount of preaching or coercion could evoke.

This experience, repeated a thousand times, has convinced me that good ends of peace and security and freedom can be achieved only by good means of friendship and cooperation and love. I doubted that truth until I tested it myself as an individual. But I have tested it, and I have seen it work again and again and again. Now I believe it with all my heart. Good ends for individuals and for nations can only be achieved by good means.

DAVID RICHIE *was a teacher, lecturer, and lifetime social activist. From 1940 to 1973, he was the executive secretary of the Friends Social Order Committee of the Philadelphia Yearly Meeting. In 1946, Richie went to war-torn Poland for relief work, and he also helped with reconstruction in Finland, Germany, Italy, and England. In Philadelphia, he founded weekend work camps, where he brought student volunteers into needy neighborhoods to refurbish homes. Richie died in 2005 at the age of ninety-seven.*

A New Look from Borrowed Time

RALPH RICHMOND

JUST TEN YEARS AGO, I SAT ACROSS THE DESK FROM A DOCTOR
with a stethoscope. "Yes," he said, "there is a lesion in the
left upper lobe. You have a moderately advanced case..." I
listened, stunned, as he continued, "You'll have to give up
work at once and go to bed. Later on, we'll see." He gave
no assurances.

Feeling like a man who in mid-career has suddenly been
placed under sentence of death with an indefinite reprieve,
I left the doctor's office, walked over to the park, and sat
down on a bench, perhaps, as I then told myself, for the last
time. I needed to think.

In the next three days, I cleared up my affairs; then I
went home, got into bed, and set my watch to tick off not
the minutes but the months. Two and one-half years and
many dashed hopes later, I left my bed and began the long
climb back. It was another year before I made it.

I speak of this experience because these years that passed
so slowly taught me what to value and what to believe. They
said to me: Take time before time takes you. I realize now

that this world I'm living in is not my oyster to be opened but my opportunity to be grasped. Each day, to me, is a precious entity. The sun comes up and presents me with twenty-four brand-new, wonderful hours—not to pass but to fill.

I've learned to appreciate those little, all-important things I never thought I had the time to notice before: the play of light on running water, the music of the wind in my favorite pine tree. I seem now to see and hear and feel with some of the recovered freshness of childhood. How well, for instance, I recall the touch of the springy earth under my feet the day I first stepped upon it after the years in bed. It was almost more than I could bear. It was like regaining one's citizenship in a world one had nearly lost.

Frequently, I sit back and say to myself, *Let me make note of this moment I'm living right now because in it I'm well, happy, hard at work doing what I like best to do. It won't always be like this, so while it is, I'll make the most of it and—afterward, I remember—be grateful.* All this I owe to that long time spent on the sidelines of life. Wiser people come to this awareness without having to acquire it the hard way. But I wasn't wise enough. I'm wiser now, a little, and happier.

"Look thy last on all things lovely, every hour." With these words, Walter de la Mare sums up for me my philosophy and my belief. God made this world—in spite of what man now and then tries to do to unmake it—a dwelling place of beauty and wonder, and He filled it with more goodness than most of us suspect. And so I say to myself, *Should I not pretty often take time to absorb the beauty and the wonder, to contribute at least a little to the goodness? And should I not then, in my heart, give thanks?* Truly, I do. This I believe.

RALPH RICHMOND *was an advertising copywriter with the Ward Wheelock Company. He was a writer of verse and essays, and he won the Saturday Review of Literature Prize for completion of the last unfinished novel by Joseph Conrad. He was a staff member of the original This I Believe project.*

The Anchor of Life

THEODORE ROOSEVELT III

I REMEMBER AS A CHILD TAKING PRETTY WELL FOR GRANTED THE FACT that we lived an intensely happy and particularly close family life. It never occurred to me to wonder that Father, busy and hardworking as he was, could still find ample time to be with his children, teaching them to play games, camp out in the woods, fish, shoot, and learn how to be good sports.

Upon growing up, it became increasingly evident that my family was particularly fortunate in our relationships to each other. Without great wealth, we enjoyed all the things that really count in youth. I learned to appreciate this fact and to value it highly. Now with a family of my own, I find that the time I'm able to be at home provides the perfect balance for the hectic rush and nervous strain of the competitive business world of today. This, I believe, is my anchor in life, the unchanging constant providing me with the correct perspective on life and the world at large.

There have been days in my life which seemed to consume all my energy and yet, which at the end, appeared totally wasted, leaving me tired mentally, exhausted physically, and

thoroughly discouraged. If I remain close to my business problems after work, there is almost no chance of achieving the detached view necessary to relax and recover the mental balance required for success and happiness. When I get down in the dumps, feeling cross as a bear, and finding little good in anything, I find the only sure cure lies at home. My wife is only too well acquainted with the myriad variations in humor of her husband returning from work and seems quite successfully to have developed a remarkable knack of diversionary tactics calculated to snap him out of unreasonable and senseless moods.

She knows exactly when to sympathize and cajole and, just as important, when not to—when to pin my ears back. She knows when to discuss business and unravel problems with me or when to launch into a series of amusing and diverting trivialities. I believe that it is because of our having been successful in developing a happy home that we have achieved this real understanding and companionship. Without it, I am sure, both our lives would seem empty and meaningless.

My son and I often spend time in our cellar workshop toiling pleasantly on joint projects of no earthshaking importance in themselves but which provide an excellent opportunity for us to grow up together. Oddly enough, it is at times such as these with a mind wiped clean of material cares that the solution to some nagging problem will suddenly appear with surprising ease and simplicity.

During the Second World War, I was one of the millions of fathers separated from their families. I firmly believe that the remembrance of my family as a unit, rather than as individuals, was of inestimable help in bridging those years. My family means all these things to me. But of far greater importance, in my book, is the sense of fulfillment, of what

I believe to be man's real reason for existing: the creation of a happy unit of society, his own family.

THEODORE "TED" ROOSEVELT III *was the grandson of President Theodore Roosevelt. After graduation from Harvard University, Roosevelt served in World War II as a flag lieutenant in a naval air unit in the Pacific, won an Air Medal, and was discharged as a lieutenant commander in 1945. After the war, he became a stockbroker for the firm Montgomery, Scott and was made a partner in 1952. Roosevelt died in May 2001 in Bryn Mawr, Pennsylvania.*

Suffering Is Self-Manufactured

Dr. Leon J. Saul

I BELIEVE THE IMMEDIATE PURPOSE OF LIFE IS TO LIVE, TO SURVIVE. All known forms of life go through life cycles. The basic plan is birth, maturing, mating, reproducing, death. Thus, the immediate purpose of human life is for each individual to fulfill his life cycle. This involves proper maturing into the fully developed adult of the species. The pine tree grows straight unless harmful influences warp it. So does the human being.

It is a finding of the greatest significance that the mature man and woman have the nature and characteristics of the good spouse and parent, namely the ability to enjoy responsible working and loving. If the world consisted primarily of mature persons—loving, responsible, productive toward family, friends, and the world—most of our human problems would be resolved.

But most people have suffered in childhood from influences which have warped their development. Hence, as adults, they have not realized their full and proper nature. They feel something is wrong without knowing what

it is. They feel inferior, frustrated, insecure, and anxious. And they react to these inner feelings just as any animal reacts to any hurt or threat: by a readiness to fight or to flee. Flight carries them into alcoholism and other mental disorders. Fight impels them to crime, cruelty, and war. This readiness to violence, this inhumanity of man to man, is the basic problem of human life, for in the form of war, it now threatens to extinguish us.

Without the fight/flight reaction, man would never have survived the cave and the jungle. But now, through social living, man has made himself relatively safe from the elements and the wild beasts. He is even learning to protect himself against disease. He can produce adequate food, clothing, and shelter for the present population of the Earth. Barring a possible astronomical accident, he now faces no serious threat to his existence, except one: the fight/flight reaction within himself.

This jungle readiness to hurt and to kill is now a vestigial hangover, like the appendix, which interferes with the new and more powerful means of coping with nature through civilization. Trying to solve every problem by fighting or fleeing is the primitive method still central for the immature child. The later method—understanding and cooperation— requires the mature capacities of the adult. In an infantile world, fighting may be forced upon one. Then it is more effective if handled maturely for mature goals. Probably war will cease only when enough persons are mature.

The basic problem is social adaptation and biologic survival. The basic solution is for people to understand the nature of their own biological, emotional maturity, to work toward it to help the children in their development toward it. Human suffering is mostly made by man himself. It is primarily the result of the failure of adults, because

of improper child rearing, to mature emotionally. Hence, instead of enjoying their capacities for responsible work and love, they are grasping, egocentric, insecure, frustrated, anxious, and hostile.

Maturity is the path from madness and murder to inner peace and satisfying living for each individual and for the human species. This, I believe, on the evidence of science and through personal observation and experience.

DR. LEON J. SAUL *was a professor of clinical psychiatry at the University of Pennsylvania School of Medicine and was considered one of this country's leading authorities on psychoanalysis. Many of his thirteen books, including* Emotional Maturity *and* Basis of Human Behavior, *focused on emotional development in childhood and the impact on adulthood. Saul died in 1983.*

The Necessity of Opportunity

HENDERSON SUPPLEE JR.

I'M GOING TO EMPHASIZE JUST ONE SEGMENT OF MY PERSONAL creed. One of the earliest, definite influences on my life was the story of my grandfather's earliest experience. As a young man, he left his home in Pennsylvania to start a business career in Virginia. The outbreak of the Civil War forced him to abandon his new home and his business establishment. He retained only a horse and carriage, which he used to drive his wife and their infant son back to Pennsylvania, where he faced the problem of how to support a young family. Despite a series of crushing disappointments, he finally built up a small dairy business. He was always confident that the opportunity existed to achieve success if he tried persistently enough. And so, the word "opportunity" has come to have a very intimate and significant meaning for me.

In many lands, the opportunity does not exist for people to achieve beyond the positions of their birth or to rise again after they have been knocked down by misfortune. My grandfather's experience has caused me to believe that opportunity, as we

know it in this country, is one of the most precious ingredients of our system. Of course, I use the term in the broad sense: the opportunity for people to carve out useful careers for the benefit of their families and communities.

Opportunity by itself is empty without the prospect of satisfying reward. My concept of satisfaction may be different from somebody else's. To me, the highest satisfaction derives from achievement, and I don't mean the glorification of personal success. Thomas Carlyle's writings brought the message home to me in college. I remember his earnest lines: "Whatsoever thy hand findeth to do, do it with thy whole might."

As a youngster, I enjoyed modeling in clay. As a businessman, I enjoy helping to model an enterprise in which men and women can profitably use their skills and resources for the benefit of themselves, their families, and the public they serve. Thus, I believe that the infinite capacity for taking pains is essential to high achievement in business and all other useful walks of life and will be as rewarding for other earnest, thoughtful people as for the genius who molds a raw lump of clay into a museum piece.

As I think about it, I have realized that even my community activities have been motivated by a strong conviction of the part that opportunity plays in our way of life. For example, most people refer to hospitals and related social agencies as "charities." Some time ago, I began to work for these institutions, and they ceased to have, for me, the patronizing significance we associate with the term "charity." Instead, I see them as necessary parts in the pattern of a community. Without them, a large city simply couldn't cope with its human problems.

Through our great networks of privately supported agencies, opportunity is preserved for countless people to

achieve normal and useful lives. Believing, as I do, that this preservation of opportunity is vital to our system, I not only feel a responsibility but also find satisfaction in helping with such enterprises. Somehow there is ample reward from the sense of better balance in my personal life and a sense of belonging to my community.

HENDERSON SUPPLEE JR. *was born in Philadelphia and graduated from Princeton University. He started work in the family business, a local dairy farm, and then worked as vice-president, president, and then chairman of the Atlantic Refining Company, where he retired in 1965. He was an active trustee of schools, colleges, and hospitals, and he served on the boards of many Philadelphia organizations, including the Chamber of Commerce. Supplee died in 1992.*

Glorious Interdependence

ELIZA TALBOTT THAYER

FIRST OF ALL, I BELIEVE IN GOD. EVERY DAY THAT I HAVE LIVED, everything I have learned, every experience that I have had has ultimately deepened and strengthened that fundamental belief. The great, mysterious universe, the majestic rhythms and harmonies, the intricate point and counterpoint partially scored for us by astronomers and physicists—all these insist upon the reality of a creator. Even more so does the existence of beauty, and of courage, and of love in the human heart. However, my faith is founded on something simpler and more direct. Occasionally, at unremarkable moments in daily life—once or twice in the presence of death or of birth—I've had such an overwhelming sense of God that I *cannot* doubt.

My life so far has been an exceptionally privileged one. I have never had any shattering personal disaster, I have never known poverty, nor have I ever actually known anyone whom I considered an evil person. Like most women whose chief job is being wife, mother, and housekeeper, I've been lucky enough to nearly always be working with and for

people I love. If the hours of my days were spent with those with whom I had no bond of affection, perhaps the power and importance of love would not loom so very large in my thinking. As it is, I can no more doubt that the love in the world comes from God than the light that fills this room comes from the sun.

I believe that there is a life after death. What form it takes—or how or why—doesn't concern me very much. The reason, I believe, is simply that even the idea of a city paved with gold is not as fantastic to me as the sudden and complete extinguishing of an individual because the heart ceases to beat. I cannot believe that the understanding and the wisdom that have grown through a lifetime, the love, the knowledge—in other words, the soul—is dependent for its existence on the material body.

The most troubling thing to me about my faith is my lack of understanding about prayer. I have never been able to feel that asking God for anything particular, even for increased understanding, is possible. I cannot pray for protection or for any special mercy of God, for any particular one of his children. It doesn't seem right to me. This inability to pray in the accepted sense of the word has been painful when those close to me have been in trouble or in danger. The nearest I can come to prayer is to try to open the heart to love and praise and a consciousness of God's plan.

I believe that there is no such thing as independence, only a glorious interdependence, that we are united with every human being in the world. We must not only love others, we *are* others; we not only must share, but we *do* share what we think, what we do, what we are, with everyone whose lives we touch. The obligation to give of self to the limit of ability seems very clear to me, and the greater the opportunity, the greater the obligation. I believe that only

as we increase in understanding and love of our fellow man can we come close to God.

> *Shared experiences with her father's explorations in Canada's wilderness, paired with her mother's passion for the arts, nurtured* ELIZA "LILAH" TALBOTT THAYER's *beliefs. She and her husband, Ted (Frederick Morris Thayer, also a 1950s This I Believe essayist), found inspiration and fulfillment on their Crum Creek farm, a vibrant, welcoming haven for all. Thayer received the Distinguished Daughters of Pennsylvania Award as an "eminent sculptor and brilliant humanitarian."*

The Obligation of Enjoying Life

Dorothy Thomas

I BELIEVE YOU SHOULD ENJOY LIFE WHETHER YOU LIKE IT OR NOT. Life not enjoyed is wasted. After frustrations, despair, after each blow to the heart, I find myself springing up from the ashes in a kind of angry defiance, crying, "Look here, this is enough. It's time you enjoyed life again."

The dreams of most and the hard facts of our lives are poles apart, and we spend our lives trying to bring the two into focus. It is this struggle—in which, undeniably, some are better equipped, more skillful, or luckier than others—that gives impetus to living. But if this struggle blinds us to the pleasures inherent in daily life, if it robs us of the ability to enjoy the passing scene, then earning a living or achieving success has plucked our daily living bare.

We all know so-called successes who lead miserable, unhappy personal lives because they do not know how to live. On the other hand, there are those whose lives lack the outward trappings of success but whose personal relationships are so right, whose inner resources so deep, who know so well

how to taste and savor the multicolored aspects of life, that they must be counted artists at living.

Each of us has a pattern of certain physical environmental needs in which we function best. One must be able to live without daily friction and so be released for the small, good enjoyments that lie all around us. One must do one's duty, meet one's obligations.

But these essentials behind us, what are the requirements for enjoying life? Perhaps most of all, one needs curiosity, an awareness of life, a sense of wonder, a child-like need to know. There are innumerable delights which, if we were really alive to them, would do much to compensate for our disappointment in the main issue of our lives or embellish a life that has more nearly fulfilled itself.

There is silver rain, the sound of wind in the trees, the smell of linden blossoms or fresh baked bread. There are clouds and bright skies. There is sunshine to touch you like a friend. There is a joy of walking on a hard, flat beach with a white-fringed ocean lapping at your feet. There are flowers, music, the world of art, the eager faces of children. There is a joyful crackling of a fire on a hearth, the pungent smell of wood after rain, the taste of strawberries warm with the sun. There is candlelight and good talk. There are dresses and hats, sherry and tea, and the safe escape of work. There are books to transport and enchant, to help chart life, to point the way. On soul-shriveling nights when thoughts hang like bats on the mind, there are books that save one's sanity, that lift the sin of sadness from one's soul.

It seems ungrateful not to respond to sunshine and sky and the very air about us, rude to God or whatever powers that be. I feel embarrassed, ashamed, apologetic when I

wallow too long in the slough of despond. I have a deep if an inexplicable conviction that somehow it is wicked to be long unhappy. This, I believe. I believe it in my bones. And I hope life will never beat it out of me.

DOROTHY THOMAS *was born in Philadelphia, where she made her social debut, but she left to become a volunteer worker in a mission in Virginia. A freelance writer, she lived in the mountains of Kentucky, Virginia, and North Carolina, where she wrote many stories of the mountain people. She was also a columnist and feature writer and worked in public relations.*

One Who Loves His Fellow Man

EDWARD D. TOLAND SR.

WHEN I WAS TWENTY-EIGHT, UNMARRIED, AND A SELFISH, SNOBBY, carefree, and vain young Philadelphia dancing man, I had a very sobering experience, which changed the entire course of my life. This sounds as if I had joined Alcoholics Anonymous, but it wasn't that.

I was in the investment banking business and taking a holiday in Europe when World War I broke out. I joined a French mobile field hospital, being able to speak French fluently, and was on the Marne in some fronts from September 1914 until March 1915. I carried stretchers, gave anesthetics, dressed wounds, was an operating room orderly, saw men die of tetanus convulsions, and saw so much of suffering and death they became just part of the day's work. I also saw extraordinary bravery, coolness under fire, and utter self-sacrifice on the part of soldiers, doctors, and nurses.

After that, I made the decision to quit business and return to my old school in New Hampshire, to teach history and coach athletics. And I did it against the advice of practically every friend, except the girl that I subsequently married.

I believe and know that teaching can be a lot of fun if done on a cause and effect basis. Exact knowledge, plus interesting highlights from collateral reading, plus a leavening sense of humor, can make it entertaining for both teacher and classes. Mere memorizing of dates, facts, kings, and battles can make it dull drudgery.

I've seen a good deal of leadership—both good and bad—in business, in the war, and in public life. And I believe that the qualities necessary for it are exact knowledge, sustained effort, honesty, tolerance, moral courage, delegation of authority, and humility. Very few leaders, like Franklin and Lincoln, have been able to combine all of them. Showmanship is also fairly important to the salesman and politician but is not essential.

I also believe that the ability to retain humility is far more important than is generally supposed. Look what the lack of it finally did to Louis XIV, XV, and XVI; George III; both Napoleons; Mussolini; Hitler; and the thousands of others in all walks of life.

I believe the philosophy of "Abou Ben Adhem," by Leigh Hunt. It is too long to quote in full, but it is about a man who awoke one night and saw an angel standing in his room. He told the angel that he was uncertain about his own religious faith and humbly asked to be recorded as "one that loves his fellow men." The next night, the angel returned and showed him that his name led the entire list, not only in love of man but in love of God. That is all that I believe anyone could ask or hope for. If one actually lives by and practices the Golden Rule, I believe that he is doing God's will and serving Him.

EDWARD D. TOLAND SR. *was a native of Philadelphia and graduated from Princeton University. At the start of World War I, he joined the French Ambulance Corps and became a captain. After the war, he became a teacher, first of French and then of history. Toland was a Republican member of the New Hampshire legislature and unsuccessfully ran for Congress in 1934. He retired as head of the history department of St. Paul's School in Concord, New Hampshire. Toland died in 1964.*

A Delicate Balance

GILBERT F. WHITE

I HAVE STUDIED MANY STREAMS, FROM THEIR RUSHING MOUNTAIN headwaters to their sluggish tidal mouths; great giants of rivers; tiny tributary brooks; streams flowing from clear springs; streams disappearing in sandy deserts. In all of them, one finds the same forces of nature at work, making for the slow carving out of valleys and for the enrichment of plants and wildlife.

Everywhere there is a delicate balance among water, soil, plants, and animals. Man can change this moving balance of nature for the good by stabilizing it at new levels and by adding new harmonious elements, as when he stores the water of ephemeral streams to create green oases. Or he can throw it out of balance by selfish or ignorant use of resources, so as to set in motion a vicious chain of destruction, as when he slashes a forest and launches a whole new cycle of soil erosion.

Whether one explores the nearby stream or the mysteries of interstellar space, one finds order and a sense of divine direction in the physical universe. A biologist in his

laboratory learns that there is law of mutual aid, which is dominant in the animal and plant world. Each of us learns for himself in the innermost laboratory of his conscience that there is a law of love among mankind. I believe that this is the law which Jesus preached. This is the law which He lived, supremely.

I believe that each of us finds greatest use and greatest satisfaction in a life which respects and kindles the spark of the divine that is found in the conscience of every other member of the human brotherhood and which nourishes the harmonious growth of individual men and women. To set the welfare of any national or racial group ahead of the development of individuals, or to coerce individual expression of thought and worship, is to unloose a destructive erosion of human values to gain the temporary prosperity of a state. While watching the German occupation of France, I became convinced that man can no more conquer or preserve a civilization by war than he can conquer nature solely by engineering force.

The good life, like the balance of all the complex elements of a river valley, is founded upon friendly adjustment. It changes slowly, but it leads always towards a more fruitful development of individual men in service of each other. It embraces confidence in fellowship, tolerance in outlook, humility in service, and a constant search for the truth. To seek it in our own lives means imperfection and disappointment but never defeat. It means, I believe, putting ourselves in harmony with the divine order of love, with the great stream of forces that slowly are shaping—in spite of man's ignorance and selfishness—an enrichment of the human spirit.

GILBERT F. WHITE *is often referred to as the "father of floodplain management." Widely known for his work in geography, public policy, water resources, and environmental initiatives, White was known worldwide for his work on floodplain management and the importance of sound water management in contemporary society. He was president of Haverford College from 1946 to 1955, taught at the University of Chicago, and retired from teaching at the University of Colorado. White died in 2006 at the age of ninety-four.*

Section II

From Contemporary Philadelphians

Open House

Helen Cunningham

THE OTHER DAY I MADE MYSELF A DINNER: SLICED TOMATOES, sliced chicken, and—o joy—potato chips. It was my idea of perfect solitude—a no-fuss meal with the just arrived *New Yorker* magazine.

As I lifted my fork, the knocker sounded. "Shucks," I thought, "he's early." It was a stranger, an artist arriving from California, a Mexican who would spend three nights with us to do his work as part of a big project in Philadelphia. So I made another plate and began to get to know Enrique. I was richly rewarded. It turns out we have common friends; we collect masks and are interested in Latino crafts; and we both go for potato chips.

This is the tenor of life for me. This inviting in of strangers has been part of my life since I was a child. My mother came from Mexico as a foreign student. Her warm experience with her host family made us into a perpetual host family. My father was an only child raised in South Philadelphia, but he found himself the father of eight children; the relative of exotic foreigners from Mexico,

Costa Rica, and Switzerland; and the host to an ongoing collection of international students and visitors.

Dinner time at our house—when we were alone—had a minimum of ten, but we often had, for example, our Costa Rican cousins who were going to school in Philadelphia for a year, a Nigerian studying at Drexel, and my older brother's buddies. Thanksgiving looked like the United Nations in session. We learned about history, geography, social justice, manners that struck us as bizarre, how humor is universal, and foods.

We always had a full guest room, and fascinating for us children, we saw all kinds of pajamas. Some of these strangers became lifelong friends.

Each generation has traded children for summers all over the globe: my sister's kid rode horses in Italy, my son learned dirty words in Costa Rica, and this summer, my niece became a fan of Colombian food.

Like my father, my husband took to the open-door policy. And so he and I have continued the tradition of having strangers as guests: artists doing residencies at local organizations; sick people coming for treatments in Philadelphia; friends of friends; friends of relatives; students.

The architecture of our house makes it easy for visitors— and for us—to have privacy and quiet. It wouldn't work otherwise, but the time spent together with our strangers has made our lives fuller. Because of the strangers who have become friends, my husband and I have been to a wedding in Colombia, we had tours of Ireland and the Baltics, and we visited friends in India. Our Bosnian student came to us during the Bosnian war; she stayed for college, a PhD, and marriage to an American and now has a daughter of her own. She is as close to us as a daughter, and her daughter is like our granddaughter.

How could I not believe that opening your house opens your heart?

HELEN CUNNINGHAM ran a charitable foundation in Philadelphia for a quarter century. She is a mediator, volunteer, traveler, and host.

The Luck in Hard Work

BERNARD DAGENAIS

BROADCASTER ED BRADLEY IS CREDITED WITH SAYING THE HARDER he worked, the more luck he had. He was partly right.

I believe being lucky makes you work hard too. One feeds the other. Perhaps the greatest luck one can have in life is to see the value in hard work and to figure out where effort is best applied.

Hard work was part of my childhood on a Vermont dairy farm. My brother, sisters, and I all had our assigned chores. But our mother was clear that our most important job was succeeding in school. She set an example by studying for and receiving her general equivalency high school degree when I was fourteen. We were all expected to go to college, and we did.

Like many teenagers, I took my family for granted. I goofed off, jumped from dangerous cliffs into rivers, and crashed a motorcycle more than once.

When I failed to work hard enough, I learned what it felt like to be disappointed in myself. I also saw enough success as a student to discover strengths and aptitude.

When I decided to study journalism in college, it wasn't much more than a guess. My turning point came when a professor sent me to conduct random interviews on a public bus and find a story to write. I was immediately hooked on having the license to ask questions, study topics, and share what I learned. I saw this as a way to make a difference in the world.

That assignment came at a good time and led to hard work—honing my skills as a journalist. Being at the right place at the right time helped me get my first job as a reporter. That, in turn, led to my first editor job at the age of twenty-seven. My early management experience gave me opportunities to grow and eventually become a journalist in Washington, D.C.

I ended up in Philadelphia after being transferred from a newspaper that was going out of business. The new job opened up just in time. Despite some hard work and initiative, I could have easily been laid off instead.

I believe luck factors into so much—the teachers we get, the people we end up working with, the timing of an opportunity, and whether we are ready to take advantage of the opportunities that come before us. But luck is not something to wait around for.

As a father now, I teach my children that nothing is more important to their futures than the decisions they make. I encourage them to leave little to chance.

You have to be good, I tell them, but it sure is good to be lucky.

BERNARD DAGENAIS *is president and CEO of the Main Line Chamber of Commerce. His background includes eight years as editor of the* Philadelphia Business Journal, *which during his tenure was the most award-winning publication among forty American City Business Journals nationwide. The Main Line Chamber is a ninety-four-year-old peer-to-peer organization that connects its members with business, leadership development, and talent. It is particularly known for its leadership programs for women and other rising star executives.*

Listening to the Clay

Liz Dow

I BELIEVE IN LISTENING TO THE CLAY.

When I was a young girl, my father would drop me off at art class every Saturday morning. Classes were held in the basement of an old mansion that had been converted into an art school. I loved that basement. I'd wash my paintbrushes and watch a rainbow of colors drip and slide down the drain. To this day, the smell of a musty sponge brings me right back to that beloved studio.

I was determined that at some point my own children would take Saturday art classes a generation—and halfway across the country—from my own childhood. I cherished these mornings, sitting next to my children, watching them turn clay into dragons and bears. If the glaze didn't turn out like we thought, our wise teacher would tell us with glee that our unexpected colors were "gifts from the kiln."

She was encouraging us not to judge our work—and ourselves—so harshly but to be free to embrace unexpected

outcomes. What a liberating antidote to my corporate state of mind: to be open to new ways of seeing things, creating, and solving problems—without judgment.

My son started class at age six. When he was handed his first ball of clay, he pushed his finger deeply into the center and said, "Mom, I can feel the heartbeat of the clay." This was the beginning of a lifetime of learning from my children. Years later, when I would get particularly frustrated with my inability to make the clay take the shape I had envisioned, I remembered my son's discovery. I took the pulse of the clay. I asked what it wanted to be. I discovered that my best pieces are done in partnership with the clay.

The work I do in the studio informs and energizes the work I do as a professional, as a developer of leaders. I have learned to take the pulse of life, to take note of what other people want—and need. Now I know that leadership is about collaboration and partnership. In softening my bottom line orientation, I get better results.

I believe that the joy of losing myself in the quest to shape a perfect curve empowers me to take on more difficult challenges in all of life. Perhaps most important is the realization that listening to the clay has brought me to a level of focus and presence, connection and sense of possibility, that makes me happier and far more productive.

Now, wherever I am, I remain open to the "gifts from the kiln."

LIZ DOW *is the CEO of Leadership Philadelphia, a nonprofit organization that mobilizes professionals to serve the community. She has done pioneering work putting Malcolm Gladwell's ideas about "connectors" into action by researching—and teaching—connection.* Fast Company *magazine called her one of fifteen superconnectors. On any given Saturday, she can be found in the clay studio, creating pieces that reflect the wonder that she finds in her work and the beauty that surrounds us.*

Life Is Hard; Pork Sandwiches Help

Barbara Earle

I was well along in life before I really believed that life was hard—for everybody. You'll probably say, "No kidding. I knew that." Well, I didn't. Around me, life seemed fairly secure and happy. I came from a hardworking family, and though we were by no means rich, a meal was never more than a few hours away. I've always slept with a roof over my head, and we loved and respected each other.

As life went on, I began to see that sooner or later, just about everybody has to deal with some heart-wrenching difficulty: someone's idyllic marriage falls apart; a neighbor loses a child to drugs; an old friend e-mailed me to say she had colon cancer. Her rapid decline and death devastated her young adult children and her husband. But she had reached out to me and some other close friends, and during her last days, she was surrounded by loving family, friends, and even laughter. She wasn't alone.

Which brings me to the other thing I have come to believe: the warmth of human connections can make even the hardest parts of life bearable. My own experience with

the hardness of life and with the saving grace of human connections began when I was diagnosed nine years ago with primary peritoneal cancer, a form of ovarian cancer.

When the dust settled after the first shock and disbelief, I was aware of circles of support around me, starting with my family—my kids and my ever-supportive husband, on whom I dump my darkest thoughts and thus lighten my load. From there, my support extended outward to close friends and then to less close friends and neighbors who rallied around.

I've had many more rounds of chemo since then. And, surprisingly, this has given me another circle of sustaining human connections. When you're in the labyrinth that is cancer care, your path keeps intersecting with others on the same journey. I get treatment at the University of Pennsylvania, where my kids were born and where I've never had anything but wonderful care. For the first eight years, I received my treatments, which could be several hours long, in rooms with other patients. It was a friendly atmosphere. People read or dozed. I sometimes knitted or did the crossword puzzle. But as we sat in lounge chairs getting infused with God-only-knows-what poison, we swapped war stories and advice for coping with side effects, but just as often, we talked about kids or grandkids, travels, or where to get the best pork sandwich—life-affirming topics all.

Last year, my cancer treatment at Penn was moved to the spiffy new Perelman Center for Advanced Medicine. Here, the new chemo suites consist of private rooms outfitted with HD TVs. Gone are the communal treatment rooms.

I don't know how things will go from here, but I'm sure it will be hard at times—for everybody—and I'm just as sure that the warmth and generous spirit of friends and family will help me through.

Recently I went in to get a routine blood draw. From across the lab I heard a voice say, "Is that Miss Barbara? Come here and give me a hug," as one of the phlebotomists approached and clutched me to her ample bosom. Now if that bit of warm, human connection doesn't help get you through a rough patch, I don't know what will.

BARBARA EARLE *was a witty, no-nonsense woman who knew how to appreciate life. She lived in Philadelphia and lived life to the fullest with friends and a large extended family constantly around her. More often than not, she did the cooking. Earle wrote this essay in 2010 and died in April 2011.*

A Balanced Approach to Life

BISHOP DAVID G. EVANS

ONE OF THE KEY WORDS IN MY LIFE IS BALANCE—THE ACHIEVEMENT, maturity, integrity, and consistent need for a balanced approach to life. As a younger man in my twenties, my first real lesson was that balance is not what has been historically taught or, should I say, traditionally understood. Balance then was a picture of a straight line with all of my priorities evenly distributed along that line.

Then, reality taught me that life would not allow me to consistently and evenly address those priorities. Priorities are circumstantially sensitive. Real life is more like a juggling act—several balls always in the air, all the balls at different levels but all under control. I've found a present crisis will cause a shift in my immediate priorities, and as the crisis passes, my original sense of balance returns. The problem in my twenties was that my approach to life was not consistent.

Now, as I matured, I found the integrity of balance was achieved when the spiritual integrity of my life changed. I was making the classic mistake of a capitalist—thinking that achievement, education, and wealth were the hallmarks of

a balanced life. But I realized I was missing something. I had emotional, professional, and social integrity but was lacking in consistent spiritual integrity.

Then I experienced a defining moment. It was one of those critical moments representing a milestone as well as what I call a destiny-impacting crossroads. I realized the need for God.

I had this friend as a child who was very overweight. My playmates and I, usually three or four of us, would climb onto one end of the seesaw at the playground. Of course, all of our feet were on the ground—no movement, no elevation, as well as no fun. Then my friend would come and sit on the other end of the seesaw. The first thing we would experience was balance. He, alone, would balance the seesaw. The integrity, the purpose for the seesaw was suddenly apparent again. That's what happened when I began a spiritual relationship with God: balance and purpose became apparent. It was my own version of a parable.

The lack of balance and spiritual integrity were key elements in a lack of real purpose. I found, in really trying times, that I needed to believe in something other than my own abilities and achievements. They were all on one side of the seesaw when God sat down. There was a feeling of elevation and movement I had not experienced. Achievement was prioritized, maturity accelerated, and a standard of integrity that helped me manage previous restrictive and challenging situations became really real for me.

I'm now in my fifties. The transition from the challenges of the 1960s and '70s to the needs of the present require a more balanced approach to successfully navigate the social, economic, and political challenges we all are facing.

For me, a balanced approach, with an acute awareness of the big picture, is essential.

Bishop DAVID G. EVANS *is pastor of the Bethany Church in Lindenwold, New Jersey, the headquarter church for his Abundant Harvest Fellowship of Churches, which includes more than 175 churches in the United States, Africa, and India. Bishop Evans is past chairman of Lincoln University's Board of Trustees and is currently on the board of Goodwill Industries. He is the author of two books,* Healed Without Scars *and* Dare to Be a Man, *and he hosts the radio program* OnPointe!

To Recognize Our Humanity

PEGGY FAGAN

DRIVING HOME FROM WORK AFTER MY HOUR-LONG COMMUTE every day on a long, winding, country road, I passed a house where an elderly man sat on his front porch, rocking slowly in an old glider. I had been introduced to him only once when I first moved in to my home. For these past fifteen years, I have lowered my window, given my horn a tap, waved, and shouted, "Hi, Charlie." I felt compelled to acknowledge him in this way because I could not imagine going through a day without hearing someone say my name. I felt he needed to hear his name spoken at least once, if only by me, a relative stranger.

I used to wave at his wife, too, when she was out walking their toy poodle. She was a sweet, small woman in a long, wool coat and kerchief, no matter what the season or weather. I called her my dried apple doll grandma. I didn't know who she was, but I would slow down and say, "Hi, Grandma," and she would smile and wave back.

But then came the day that she was not out, and Charlie was walking the dog. I knew that he was now alone, and the

imperative to acknowledge him grew stronger. My window was rolled down before I came around the corner, and even if he were not on the porch, I would tap the horn and call out to him, hoping that in his aloneness he'd hear me. As long as there was a light on in the house and the blue glow from the TV screen shining out of the window, I felt that he was all right.

But the inevitable day came; Charlie's pickup truck was for sale out on the front lawn. A few days later, a realtor's sign was posted, and I knew that Charlie was gone.

I still honk and wave and yell, "Hi, Charlie" as I pass, albeit without as much gusto as I had in the past. The house is dark now.

It is my belief that all of us need to be acknowledged at least once a day—that we need to hear our names spoken aloud by another person to cement our place on this planet, to know that someone sees us and recognizes our humanity, the truth of our being. I feel that it is incumbent upon all of us to acknowledge each other each day, in this way to speak to that truth.

PEG FAGAN *lives, writes, and makes fabulous pies in the wilds of Upper Bucks County, Pennsylvania, with her life partner, Greg, and two spoiled dogs, Gus and Grady. When not wrapped up in love and play with her grandchildren, she is the executive chef and owner of The Flying Avocado Whole Foods, LLC, where she tends to work a little too hard. She is grateful to live a life that is full to overflowing, and she would not have it otherwise. Well, maybe except for the work part.*

Culture, Practice, and Transformation

Dr. Carmen Febo–San Miguel

GROWING UP IN PUERTO RICO, OUR FAMILY WAS NO DIFFERENT than so many others. My parents got married after my father came back from being stationed in the Dominican Republic when the war ended. Both professionals—my mother a teacher, my father a civil engineer—my parents were struggling with the hard economic realities of the time. But somehow, they found time to cherish those cultural values that shaped our everyday lives. We celebrated every birthday, every graduation, and all holidays with music and dancing, typical foods, and friends and family. When we visited our family in the countryside—a trip that took two hours in an un-air-conditioned car, with five children fighting as to who would get a window or the front seat— we would break out in song, and somehow the trip would turn into fun. We would sing fun children's songs but also beautiful love songs, songs about the love of country, many times not even understanding the meaning of the words.

When I was nine years old, my father took me to a classical music concert as part of the Pablo Casals Festival.

I can't remember what we heard; I can't remember who the artists were. What I do remember is asking my father why he came and why he brought me. He answered, "You know, Carmencita, I really do not understand this music, but I know I like it. I come, and I listen, and I feel." This statement taught me two important lessons: one, to be honest and unpretentious, and the other, that art is not only about knowing and understanding but, perhaps more important, about feelings.

I came to Philadelphia for the first time in 1973 to do a residency in family medicine after attending medical school in Puerto Rico. I remember the many hours of work. I was facing issues of life and death and confronting the stark social inequities and issues of poverty and race. These were all aggravated by my feeling of cultural isolation.

An important turning point in my life happened one Saturday night in 1976 when I attended a concert of Puerto Rican singer and composer Antonio Cabán Vale. The concert was held at a small performance space in a church in the heart of the Puerto Rican community in North Philadelphia. The room came alive, the music reverberated my familiar rhythms, and the words spoke to my heart. I had found a space to express, celebrate, and share my culture in Philadelphia. The organization sponsoring the event was Taller Puertorriqueño.

So, I believe in the right of cultures to coexist in a society where diversity is seen as an asset and not as a disadvantage. I believe in the right of individuals to be free of domination from others. As a Puerto Rican, I am a mixture of races. I am a mestiza, with indigenous, black, and European influences, and I believe in my strength because of this. And when I see a group of boys and girls perform the traditional Puerto Rican bomba and plena (traditions that have been

passed on for generations) with passion, pride, and fervor, I believe in race; I believe in the human race.

Healer is the word that best describes CARMEN FEBO–SAN MIGUEL. *As a physician, she concentrated for years in serving predominantly poor Puerto Rican and African American families in Philadelphia. As a cultural healer, she has put her knowledge and energy into creating a place where Puerto Rican and Latino cultures thrive. Febo–San Miguel started volunteering at the Taller Puertorriqueño in the late 1970s, eventually becoming its executive director. Her commitment to the city and its people is rooted in the cultural and social activism she learned at home.*

My Heart Belongs to Philadelphia

Frank Fitzpatrick

SOMETIME AROUND MIDNIGHT ON JULY 21, 1980, I FINISHED MY first night's work at the *Philadelphia Inquirer*. I was elated as I exited its landmark white tower and was met by the twinkling city skyline. After nearly a decade at smaller newspapers elsewhere, I finally was working for a Pulitzer Prize–winning giant. And in my beloved hometown, no less.

I believe in Philadelphia.

I know, it's not always easy. The city is dirty, crime-ridden, corrupt. Its residents are possessed of a maddening inferiority complex and at times seem to revel in negativity.

But fear and loathing are such shallow emotions. Nothing like love. I often tell people my attachment to Philly is visceral. When I'm away, I ache to return. When I'm downtown or at a South Philly restaurant, I feel remarkably connected, as if the city and I were a single living organism.

In my thirty years at the *Inquirer*, I've had opportunities to move. I couldn't do it, in large part because I knew I'd miss Philly. I couldn't imagine walking streets that had no personal meaning, celebrating Christmas without the light

show at Wanamaker's—by the way, we Philadelphians will always refer to the iconic department store building by its rightful name—or rooting for sports teams my grandfathers hadn't pulled for.

Like so many here, my roots are deep. I can hardly drive down a street in Frankford, North Philly, or Center City without experiencing some kinship.

The four branches of my family have been embedded here for a century and a half. Until the middle of the 1900s, almost all were blue-collar occupants of brick rowhouses on crowded, narrow streets.

My urge to share the wonders of this great and diverse metropolis is a powerful one. Like my grandmother, who gave impromptu tours while riding the R bus, I've become an unofficial guide, ushering visitors and suburbanites who have lost touch with Philly to places with historic and personal significance.

My wife and I are empty-nesters now. On free Saturday mornings, we like to grab a cup of coffee and take a ride. We've explored the shoddy Kensington streets and storefronts that were the setting for *Rocky*. We've eaten Stock's pound cakes, Caccia's pizza, and the wondrous long-johns at Relli's Bakery, which, sadly, like my thirty-two-inch waist, is now gone. We've driven through Port Richmond and Mayfair, Queens Village, and Southwark, and we haven't even touched the surface of this great city.

Recently, not long after one of our Saturday drives, we went to the Mann Center to see Tony Bennett. From up there on Strawberry Mansion, on a gorgeous summer evening, the city's skyline was breathtaking.

Bennett, of course, sang his signature piece, "I Left My Heart in San Francisco." As I sat there listening, surrounded by lovely Fairmount Park, not far from the scene of so many

of Thomas Eakins's greatest paintings, I knew exactly where my heart was.

And always will be.

FRANK FITZPATRICK *is a lifelong Philadelphian. He's been at the* Inquirer, *first as an editor and for the last twenty-five years as a sportswriter, since the summer the Phillies won their first World Series, 1980. He was a Pulitzer Prize finalist in 2000 and is the author of five books, including* And the Walls Came Tumbling Down: Kentucky, Texas Western and the Game that Changed American Sports. *He and his wife, Charlotte, are the parents of four and grandparents of two and reside most contentedly in Malvern.*

I Can Make a Difference

CAROL FIXMAN

I BELIEVE IN TAKING ACTION TO SOLVE PROBLEMS AROUND ME. Passively accepting the status quo is something that doesn't even cross my mind.

My mother wrote poetry, books, and letters to the editor to try to change the world—some were published; others remained manuscripts that she worked and reworked with comments that she solicited from authors she respected. She did not sit still.

When, at ninety-three, illness left her only a short time to live, she told me that she had submitted her recent book of poetry to a publisher but hadn't received a response from them. So I called the publisher, only to learn that the company had gone out of business. As my mother's health was slipping quickly, there wasn't time to find a different publisher. After a few weeks of feeling helpless, I finally stopped sitting on my hands and looked for another solution.

I found a wonderful family-owned book-binding company and a printer who agreed to produce twenty copies of my mother's book as quickly as they could. Sandy Geiser Craig

and Bernie Pond were touched by my mother's story and quickly moved into action with me. As a threesome, we worked together to complete the book just a few hours before I left to see my mother for the last time. I handed it to her gift-wrapped. Her pain medication made it hard for her to see and think clearly, and she struggled to read the title of the book I had given her. When she finally recognized her title, *The Wrinkled Nest*, she truly looked as if she had seen a ghost. Then her face softened into a smile. "You remembered," she said. And then I knew—she had expected all along that I wouldn't sit still either and let her final book remain a manuscript.

Not finding a solution wasn't an option. And this has guided me through so much of my life. I live in the world of education and opportunity. This is a daily challenge. It calls for invention and ingenuity. When faced with a problem, I can't simply shrug my shoulders and say, "I don't know."

While I can't change the world alone, I work on making it better by addressing issues that mean a great deal to me. So when I see injustice, inequality, and prejudice, I can't accept the status quo, and I need to take action. As idealistic as it may sound, I know I can make a difference. And I thank my parents for instilling this belief in me.

CAROL FIXMAN *retired as executive director of the Philadelphia Education Fund. She served previously as vice-president for academic affairs/dean of the faculty at Philadelphia University and director of international programs at Temple University. Originally from St. Louis, Missouri, she lived for many years in Germany, where she taught at the University of Bonn and developed programs for young academics and professionals. She has a PhD in German literature from Brown University. Philadelphia has been her home since 1988.*

Happily Ever After

ABBE FLETMAN

AS A GIRL, FAIRY TALES NEVER CAPTIVATED ME. I NEVER SAW MYSELF meeting a handsome prince and living happily ever after. At the time my childhood girlfriends had these dreams, I didn't understand why.

I met my partner in 1984. She was smart and funny, and I instantly connected with her. We quickly moved in together. Over time, we merged our finances and books, bought a house, and had children. We made a life together. Still, no visions of walking down the aisle in a frilly white dress filled my head.

Then our friends Andy and Larry got married. Like us, they had been together for more than twenty years. Like us, they were initially skeptical of replicating a heterosexual ritual that, for us, would carry no legal rights.

After this event, I began to think about marriage. Let's be honest: I began to obsess about it. In part, my love of a good party fueled my enthusiasm. In December 2002, I got down on my knees and asked Jane to marry me. Fortunately, she agreed.

On October 3, 2003, we took our vows under a traditional Jewish chuppah, a canopy made of our son's prayer shawl. Nearly everyone important to us was there, including my parents, who have since died, our children, and Jane's brother and sister-in-law. Most of the significant people in our lives gave us blessings.

And so, I found, I believe in marriage. Although Jane and I had lived together for more than two decades, going through a marriage ceremony felt momentous, a feeling I had never anticipated. Writing a ketubah, a Jewish marriage contract, made us articulate our promises to each other, including that one of us would care for the other partner until death. While we were committed before, the combination of the public declaration and the written pledge somehow made it more concrete.

All this has led me to believe in marriage. Yes, even at a time when half of all marriages are expected to end in divorce and fewer American couples are marrying. I had a good role model in my own parents, who never seemed to tire of each other's company in their nearly sixty years of living and working together. The strong marriages I have witnessed produce not only happier people but also greater economic security and solid family units within which to raise children.

Of course I don't believe that everyone should marry or that people should stay in bad marriages, especially if they are violent or abusive. But I do believe that marriage should be available to all couples, whether straight or gay. We should equally have the ability to communally celebrate happy occasions. We also should have the legal rights so many others take for granted. Until then, I've gotten my "happily ever after." All it took was wedding my "princess charming."

ABBE FLETMAN *is a judge in the criminal trial division of the Philadelphia Court of Common Pleas. Before taking the bench, Judge Fletman received many accolades for her work as a trial lawyer handling complex commercial cases and pro bono matters, including representing female athletes in Title IX and equal protection cases. She and her wife, Jane Hinkle, were legally married in Delaware in 2013 and hope to celebrate their thirty-first anniversary with their two adult children this year.*

Leaving the City Better and More Beautiful

LOU GAMBACCINI

THE ONLY SON OF ITALIAN IMMIGRANTS, I DEVELOPED A PASSION for government and public service at an early age. When I was eight years old, on a family trip to Washington, D.C., I was mesmerized by the nation's capital. It was September 1939, and World War II broke out while we were there. Two years later, while listening to my favorite radio program on a Sunday afternoon, I heard it interrupted by the announcement that Pearl Harbor had been bombed.

That's when I began clipping newspaper articles and tracking the progress of the war. Other boys at the time worshiped heroes in the fields of sports and entertainment; my heroes were all the military and civilian leaders of the Allies. I greatly admired the people who guided us through the Great Depression and World War II. I was thrilled to read of their decisions and their deeds, and I felt gratified that we were blessed with their courage, integrity, and determination.

I always knew I wanted a career in public service. I avidly consumed books on biography, history, politics, and war.

In college and graduate school, my education was always focused on government and public affairs.

My love of the public service continued unabated through a fifty-year public career with experiences as wide ranging as military service in Korea in the early '50s to executive positions in various public agencies. I never regretted the choice.

And I never forgot an inscription on the wall of the foyer of the Maxwell School of Citizenship and Public Affairs at Syracuse University. It was the Athenian Oath of the City-State: "We will ever strive for the ideals and sacred things of the city, both alone and with many, we will unceasingly seek to quicken the sense of public duty; we will revere and obey the city's laws; we will transmit this city not only no less, but greater, better, and more beautiful than it was transmitted to us."

That simple oath has been a source of inspiration throughout my entire career. I use the oath periodically to stimulate others in pondering their obligations as public servants. This was particularly pertinent when I was asked to direct a large department of state government and felt uneasy about prior intermittent incidents in the department, which involved financial improprieties in the management of contracts.

I was moved to use the Athenian Oath to rally a renewed commitment by the staff to ever higher standards of performance. A framed copy of the oath has remained hanging in the foyer of the department for the past thirty years and has been signed by my successors and quoted by them in innumerable speeches and house journal articles. In short, the message endures.

I believe that all public officials—elected and appointed— should be sworn to a similar oath.

LOU GAMBACCINI's *public service career has spanned more than fifty years. A national leader in the field of transportation, he created and/or led a broad range of public entities supporting the transportation needs of the public in New York, New Jersey, and Philadelphia, where he was general manager of SEPTA. As a member of the National Academy of Public Administration and similar national organizations, he has continued to champion public service throughout his career.*

Education Is the Key

KENNETH GAMBLE

I BELIEVE THAT EDUCATION IS THE KEY TO ENDING VIOLENCE—here in Philadelphia, in the United States, and around the world. Education will also be the key to ending poverty. Without education, you cannot develop individual wealth or community wealth.

What led me to these conclusions is that so many of my friends, people that I grew up with and went to school with, are either dead, on drugs, or in prison, though many others are doing well. We all get together now and then to talk about how we could have been a greater group of people if our education had been more well rounded. Educated citizens can make better choices for themselves, and education can help one to reason without so many emotions tied to their decisions.

Marcus Garvey said, "A people without the knowledge of their past...is like a tree without roots." And when I was growing up in the Philadelphia public school system, we didn't learn anything about my African ancestors. For African American students in particular, and other students in general, learning about the history and culture of African people and African

culture is very important to give balance to a subject that does not get much attention.

Slavery had a tremendous impact on the African people, who were robbed of everything—their family, their home, their culture, their whole identity. American laws prevented them from learning how to read and write, and being excluded from the learning process for many decades has taken its toll on the African American community. So when people ask today, "What's wrong with the African American community? Why is there so much violence? Why is there so much poverty?" it is this legacy of slavery that runs through it to this very day.

The first step toward correcting these problems is to talk openly about race and history. We must have a conversation about it and how to heal our community. And the best way is through education. Not just reading, writing, and arithmetic, but we have to educate people *about* people—including the truth of our history, where the feelings of low self-esteem and anger come from, and the nature of the human being.

So I believe that a well-rounded education—including science, technology, engineering, math, the performing arts, sports, home economics, music, and, of course, history—is the key to ending the cycle of violence, poverty, ignorance, war, and racism. Education is the key to our future.

A Philadelphia native, producer and songwriter KENNETH GAMBLE *is the CEO and chairman of Philadelphia International Records. He has written and produced more than three thousand songs along with his writing partner Leon Huff. Gamble and Huff have worked with such world-famous recording artists as Michael Jackson, Patty Labelle, Lou Rawls, and Teddy Pendergrass. Gamble still resides in the Philadelphia area, where he continues the furtherance of his education work.*

It's All in the Details

MELISSA WEILER GERBER

I BELIEVE IN DETAILS. I KNOW THIS RUNS COUNTER TO WELL-meaning advice that seeks to liberate us from sweating the little stuff. I am painfully aware that my conviction places me at risk for lost sleep and moments of distraction. Dare I say it may even make this forty-one-year-old a bit old-fashioned. So be it.

It's in my blood. My grandmothers remembered everyone's birthday and acknowledged all sicknesses, deaths, weddings, and other major life events with handwritten notes. My father, a lawyer and one-time English teacher, edited my early writing diligently and, along with my ninth grade grammar teacher, instilled in me the importance of a comma, the difference one word choice can make. My mother wrote a special message on the paper napkin in my lunch box each birthday during every school year.

Details bring me joy—the feel of quality paper, the heft of a rocks glass, the foam on a well-made latte. These are little gifts that lift my spirit and elevate ordinary experiences. But I also recognize that my commitment

to particulars has a dark side. I feel compelled to try on three pairs of the same size jeans before making my final choice. I have to read every greeting card in the store to find just the right one. And discovering I've committed a typo nearly kills me.

Yes, it's hard work to focus on details, but focus I must, for details are fleeting—the circumstances of a first kiss, a lost loved one's laugh, that shortcut we always used to take. Unless purposefully tended to, the components of even the most important of life's events are apt to fade and then disappear.

Okay, I'm a bit obsessed, but let's face it, it's the sum of all these details that add up to the whole person we are—the eyeglass frames we select, the unique flair of our signature, our choice of seat on a roller coaster—these things provide each of us with our own unique identity. They tell the world in a million tiny ways who we are, what we value.

This is why those things play such an important role in relationships. Taking the time to notice, acknowledge, and recall details makes those around us feel appreciated and understood. We draw on the best of our humanity when we slow down enough to listen—really listen—to a story being told. I certainly notice when someone does that for me.

And so, I pledge to try my best to remember whether you like the toilet paper to roll under or over, whether you are a cat or dog person, and the date of that big birthday you have coming up. I'll be grateful if you remember that my ears are not pierced, I like peppermint tea, and chocolate is always the right answer. Yes, I believe in details.

A lawyer by training, MELISSA WEILER GERBER *has spent most of her career advocating for underserved populations. Weiler Gerber serves as the president and CEO of AccessMatters, where she works to transform access to sexual and reproductive health in the five-county Greater Philadelphia region. Previously, she served for over a decade as the executive director of Women's Way, a nonprofit organization advancing women's equality, safety, self-sufficiency, and reproductive freedom. A cheerleader for urban living, Weiler Gerber enjoys working, playing, and raising her children, Bea and Oscar, in the heart of Center City Philadelphia.*

Making Art with Each Other, for Each Other

JANE GOLDEN

I BELIEVE THAT THE CREATION OF PUBLIC ART HAS A UNIQUE capacity to build community and to stimulate creativity.

I have loved the idea of art in public places since I was very young, when my father showed me the works of Ben Shahn and Thomas Hart Benton created for the WPA in the 1930s. I became fascinated with the art form, and when I moved to Los Angeles after college and saw the remarkable murals in LA's neighborhoods, I was further inspired.

My first mural in 1978 was an image of the historic Ocean Park Pier, an icon of Santa Monica that had been torn down years earlier. Each day, as my ragtag crew and I showed up to work on the mural, people stopped and watched—on their way to the library, the bus, or the beach. Sometimes they brought food, sometimes they brought boomboxes to play music on, and sometimes they gathered to talk to one another. Older neighbors told the younger ones about their memories of the pier; spontaneous discussions about neighborhood issues or city politics were common. Even before it was fully painted, the mural became a focal point of

energy and activity. I was amazed and thrilled by how creating art in public could engage and stimulate my diverse group of neighbors.

For several years, I continued to paint murals in LA, but I didn't fully appreciate their impact until I returned to the East Coast several years later.

In 1984, when I was hired to run an art program for the Philadelphia Anti-Graffiti Network, I began working in neglected neighborhoods where many people had nearly given up hope. These were places where the only visible city employees were the police. Here, I met block captains and community leaders, mostly elderly women, whose optimism and determination provided inspiration and role models for a lifetime.

I have vivid memories of Ms. Rachel Bagby, from the neighborhood at 20th and Dauphin, gradually overcoming her skepticism about what good "painting on walls could do" and then becoming a committed partner in the creation of community murals. She longed for a little beauty in her community, to compete with the billboards advertising alcohol and cigarettes. She saw the murals as a way to tell the stories of the people in the neighborhood. She helped gather her neighbors, and we began talking about their histories and their hopes. We painted several rural scenes to commemorate the tradition of black family farms in the South, a visual memory treasured by the elders but virtually unknown to the young people. Our partnership culminated in an enormous mural of Mount Kilimanjaro, which Ms. Bagby and some other neighbors had visited. It stood for years like a beacon on a busy street, reminding all passers of their ties to the African continent.

Since then, I have seen truant teens emerge from silent cocoons to contribute their ideas and take up brushes to create a mural. I've watched lifers in a maximum-security prison struggle to find peace and common ground with victims of crime—and then visualize that healing effort in a mural painted together. I have seen neighborhoods split by animosity and racial strife overcome suspicion and hostility while working together to create art.

I am not naïve. I don't see art as the solution to all problems. But I have seen enough evidence to know that public art is not a frill or an extravagance. Not for my community or my city, and certainly not for me. In 1982, when I could no longer use my left hand and was told I had a fatal illness called lupus, the need to paint, the drive to tell stories on walls kept me going.

I believe that art keeps us all going. And I believe that when people make art with each other, for each other, transformations occur, and the force of life triumphs.

JANE GOLDEN, *founder and executive director, has been a driving force for the Philadelphia Mural Arts Program, overseeing its growth from a small city agency into the nation's largest mural program. Under Golden's direction, the Mural Arts Program has created more than 3,800 landmark works of public art, and Golden has received numerous awards for her expertise and accomplishments. Golden holds an MFA from the Mason Gross School of the Arts at Rutgers University, as well as a BA in fine arts and political science from Stanford University.*

There Is Value in Every Person

James T. Harris

I BELIEVE THAT LIFE'S TOUGHEST LESSONS ARE BEST LEARNED through personal experience. Let me tell you a story.

Throughout my childhood, my grandmother provided me with unconditional love but always reminded me that "you are no better than anyone else, but you are also just as good as anyone." To her, it was important to treat others with dignity, no matter what their position in the world, and by doing so, you would earn respect in return.

I thought I knew what she meant, but I guess I never really understood why she was always encouraging me to treat everyone with dignity no matter their station in life.

That was until I was seventeen and got a summer job as a janitor cleaning the restrooms in some local factories in my hometown. It was a humbling experience for me. I learned firsthand what it was like to be "invisible" as I scrubbed floors and toilets and watched people walk right by me and not even recognize my presence. There were even people I knew from my childhood who worked in the factories who seemed not to remember my name. It outraged me that people couldn't

see past my job and my uniform to recognize who I was as a person. This made me feel angry and wanting to strike out at those who were treating me so poorly.

When I complained to my grandmother, she reminded me to never forget the feeling of being "invisible" and to do the best job I could because it was still my work and in that I should take pride. She also stated that it would make me a better man some day.

Make me a better man someday? She must be joking, I thought to myself. But I needed the job to pay for college and there were few other jobs available, so I bit my tongue and kept on working as best I could for the rest of the summer.

Eventually, I learned to always take pride in my own work and to respect the work of others. I pledged I would never become so self-absorbed with my own importance in life to not personally pay attention to others who might not have the same title, the same position, or the same good fortune as me.

That experience influenced me profoundly. Today, when I am asked what job helped prepare me to assume the leadership of a major metropolitan university, I tell people it was my summer job cleaning restrooms. Not the work itself, but the whole job experience. It shaped me as a man and, down the road, as an educator.

I believe that students, and all young people, should get out of their comfort zones and get deeply involved in different work and community experiences. It's essential for people to find value in every person, no matter who they are or what they do for a living.

Sure, you can learn facts from books and by taking tests, but I seek the lessons that can only be understood by walking in a lot of different shoes.

Once again, I think my grandmother was right.

JAMES T. HARRIS *is the grandson of Mollie Lind Harris and president emeritus of Widener University. He currently serves as the president of the University of San Diego.*

A Life in Government for the Sake of Doing Good

Francis W. Hoeber

I BELIEVE IN GOVERNMENT.

My grandmother, Josephine, was the first in my family to enter government service nearly a century ago. She was a doctor in the women's health clinic in Kiel, Germany. As a public health physician, she improved the lives of poor young mothers and children who otherwise would have gotten no proper medical care.

My father and mother, who fled Germany to escape the Nazis, made civil service their lifelong work here in America. Each of them built a distinguished career in agencies founded on principles of social and economic justice. So I grew up believing in the capacity of government to ameliorate human suffering and to improve the lot of ordinary people.

While I was still in college, I, too, went to work in the public sector. I was thrilled when I got a job as a summer intern for Senator Hubert Humphrey. I was able to be in the

Senate gallery when the Civil Rights Act of 1964 was passed. It guaranteed the equal rights under law that Americans take for granted today.

After college, I landed a job with the National Labor Relations Board, where we protected the rights of employees who wanted to be represented by a union. I will never forget the respect I was accorded when I entered a metal factory in Wilkes-Barre, Pennsylvania, or a nursing home in Millville, New Jersey.

I was the government man responsible for setting the rules of fair play between employees and their employers. And I'll never forget being welcomed into the small-town home of a man or a woman who had been fired for union organizing, knowing that these individuals were relying on their government—on me—to save them and their families from economic disaster. It was a huge responsibility, and the long days of hard work were repaid by the conviction that my colleagues and I were making a difference.

Now, I am a manager for the New Jersey courts. Our judiciary has created drug courts. They save the lives of addicts who were once criminals. I have worked on programs to keep kids who went wrong from being locked up in institutions that too often only increase the likelihood that they will offend again.

I leave my house at seven o'clock in the morning and I don't get home until seven o'clock at night, and in between there's hardly a minute of downtime. But I take very seriously my responsibility to do the most that can be done with the hard-earned tax dollars that pay my salary.

I believe in the good that government can do. My whole life has taught me to believe in government. No one knows the flaws of government better than those of us who labor under its maddening limitations. But government is still

the best institution that we have devised to address the panoply of problems that beset the human condition.

FRANCIS W. "FRANK" HOEBER *spent forty-five years in public service, part of that time managing the Philadelphia office of the National Labor Relations Board and part as an executive in the state headquarters of the New Jersey court system. In 2010, Hoeber left government to devote himself to historical writing. His book,* Against Time: Letters from Nazi Germany, 1938–1939, *about his parents' escape to America, was published by the American Philosophical Society Press in 2015.*

Love without Requirement

REVEREND CHARLES L. HOWARD

LOCUST WALK, THE MAIN THOROUGHFARE THROUGH THE University of Pennsylvania's campus, holds many memories for me. I'll never forget the buzz and excitement of walking along that brick-laden path as a freshman feeling both excited and intimidated by four years of possibility standing before me. I remember being initiated into my senior society, chalking the ground during that exciting night. And, of course, I'll always cherish the rainy day that was nonetheless full of sunshine when I marched in my robe toward graduation.

Locust Walk is special to me, and I'm blessed that the Office of the Chaplain is right there in the middle of it. During my first year as chaplain, while walking on Locust, I bumped into a man named Harold Haskins, a campus administrator who literally helped tens of thousands of kids make it through Penn—myself included. I asked Hask if he had any advice for a rookie. He smiled and looked at me—clearly remembering the challenges that he helped me navigate as a student many years before—and said, "Love without requirement."

It was as if Hask had summed up my life with those three simple words. Love without requirement. That's exactly how I have been loved in my life. You see, when I was eleven, my mother died in my arms. My father died when I was a teenager. I was young when I lost the only two people who were required to love me. My life trajectory did not look promising as a young orphan from Baltimore. I'm not supposed to be here. But then a number of people came to me. And cared for me. They were not required to love me. But sisters, brothers, cousins, aunts, uncles, teachers, mentors—all loved me as if I was their own. And there is no force greater than love.

I think that's part of what Hask was getting at. When we love, lives can change. But there is another aspect of loving without requirement. There is the lack of imposing any requirements on the beloved. This is loving in a way that does not depend on them performing, them being good, or even loving us back.

I and many of the faculty and staff working with amazing young women and men every day also have the great task of showing the students that their value does not depend on their grades, what graduate schools they will get into, what jobs they get, or what their salary will be. We challenge them to be their best, and we also try to love them in a way that doesn't depend on these things that come and go. No, we try to love them without requirement, without condition.

And that's not easy, is it? But I seem to do a better job at it when I remember how I have been loved.

So what do I believe? I believe that I have been deeply loved in a way that I didn't think I deserved. I believe that the purest love is one that does not depend on what we do but, rather, who we are. And I believe that the great call on all of our lives is to love and be loved. Love changes things, and I believe that with my whole heart.

The Reverend CHARLES L. HOWARD, *PhD, is the university chaplain at the University of Pennsylvania, his alma mater. Prior to his return to Penn, he served in hospice and hospital chaplaincies and as a street outreach worker to individuals experiencing homelessness in the city of Philadelphia. A son of Baltimore, Maryland, he considers himself a godson of Philly, where he lives with his wife and best friend, Dr. Lia C. Howard, and his three daughters.*

The Human Family

RABBI NANCY FUCHS KREIMER

WHEN I WAS A CHILD IN THE LATE 1950S, BEFORE I WAS ABLE to read, there was a book in my home called *The Family of Man*, a compilation of photographs that had recently been exhibited at the Museum of Modern Art in New York City. The collection was, I found out later, a "photo-biography of the human race."

I recall poring over that book during long evenings. I marveled over the fact that two eyes, a nose, and a mouth could take on such variety. These pictures were wondrous, but the awe they evoked was not entirely comfortable. I struggled to reconcile the deep sense of kinship I felt with those faces with the estrangement of being a lonely child. The conundrum of separateness and connection was bewildering, a bit uncanny.

I had a voracious thirst to learn what other people did with their deepest fears and hopes: with their solitude, their sense of connection, their awe. My family was not big on spiritual practice; however, study was a sacred endeavor. So

as soon as I could choose my own books, I began reading about the religions of the world.

When I was about fifteen, I learned something that changed my life. It happened, of all places, in synagogue school. It was a Jewish text from the first or second century. "An earthly king stamps his image on a coin and every coin looks the same. But the King of Kings, God, puts His image on every human being, and every one is different."

That felt exactly right: I was a unique coin, stamped from the very same "image" as every other. Until that moment, I had not known if I believed in God. But that text made sense to me. No person is more holy than any other. This messy reality with all its wild diversity is actually also a unity, a sacred oneness.

Now I work in a rabbinical college, creating programs that prepare students for a world of religious diversity. I believe that no matter who you are—a bearded orthodox rabbi or a hijab-wearing Muslim woman—you are, simply by virtue of being human, the spittin' image of the one and only God. My work is to bring together people whose looks, experiences, and beliefs are different, people who first encounter each other as strangers, perhaps even foes, and leave having seen the holy in each other's faces. It doesn't always happen. Truth is, sometimes it is hard for me to see the image of God, even in people close to me. This is not an easy belief to maintain. But I know it is worth trying.

Rabbi Nancy Fuchs Kreimer *is the founding director of the Department of Multifaith Studies and Initiatives at the Reconstructionist Rabbinical College. Kreimer develops courses and programs for RRC, the Greater Philadelphia interfaith community, and beyond. She is the co-editor of* Chapters of the Heart: Jewish Women Sharing the Torah of Our Lives *(Cascade Books, 2013). Kreimer served on the founding board of the Interfaith Center of Philadelphia, and she holds a PhD from Temple University in interreligious studies.*

Learning How to See

CLAIRE LAMBERTH

I BELIEVE IN THE IMPORTANCE OF SEEING SOMETHING NEW EACH time we see the familiar and seeing into and beyond the words we hear.

In high school, I had two teachers who made me aware of these concepts, although it took many years before I appreciated them fully.

One day, Mrs. Lambert, my advanced placement English teacher, brought in several baskets filled with all kinds of things, tchotchkes, bric-a-brac, and stuff. Each of us took something and wrote a composition about it for homework. The next day, the baskets reappeared, and we were instructed to select the same object. This time we had to write a composition about the object without repeating anything from the first one.

Over the next few days the same thing happened, with each day bringing an increasing sense of frustration as we tried to see something new in an otherwise uninteresting object. I will never forget the last piece I wrote about my blue and white Delft fisher boy. After struggling to find something original to say, I got inspired to write a sonnet. It allowed

me to see beyond the porcelain figurine and into the essence of the character. Mrs. Lambert had shown me how to use my own eyes and creativity to see what I otherwise would have looked at and dismissed in an instant.

The other teacher was Mr. Kramer, who taught a civics class called Problems of Democracy. At a time when the spirit of McCarthyism was still quite powerful, he dared to be liberal and open-minded. Returning from Cuba, where he fought alongside Castro and Che in the Cuban revolution against the dictator Batista, he taught us about propaganda in all its forms. We learned the techniques used in politics as well as in advertising from a teacher we all admired, a man who was unafraid of challenging the fears of the time. I never thought much about what he had taught us until I began seeing and hearing all the misleading commercials that run rampant on TV today. I see how through small print and deceptive words, the public is manipulated. I don't know if I would have the same awareness were it not for Mr. Kramer.

Fifty years later, as I remember Mrs. Lambert and Mr. Kramer, I wonder, are schools today showing kids how to use their own eyes and ears to see into and beyond the superficial? This, I believe, is the most important lesson a child can take into adulthood.

CLAIRE LAMBERTH *went to Cheltenham High School and Barnard College and then lived in Europe for a number of years. When she returned to the United States, she went to nursing school and became a psychiatric nurse. She has been retired for fifteen years and now enjoys making fused glass and silver jewelry. She and her husband travel to Europe twice a year to visit her son, who lives in London and owns two restaurants.*

The Power of Story

NATHAN ALLING LONG

WHEN MY DOG GRACIE DISAPPEARED SIX YEARS AGO, I REALLY learned what I believe. Gracie escaped from my boyfriend's backyard around 2:00 p.m. We scoured the neighborhood for hours but had no luck. She was gone. We put up fliers, and by dark, we returned home, exhausted.

On the second day, I called my vet, the SPCA, and the animal shelter. Nothing. I felt lost, defeated.

If I knew Gracie had been killed, I would have been heartbroken, but I could've moved on. If I knew she was caught somewhere, I would rescue her. If I knew she had found a better home, I would be sad yet relieved. But how do I deal with the unknown? Pray? Wait patiently? Search endlessly? Give up? I didn't know what to do, what to hope for.

The third day, while I was searching in the woods for Gracie with my friend Rhea, I confessed that losing Gracie was like losing faith in everything. Rhea smiled and said, "You know, maybe Gracie's on a great adventure." It seems strange, but I felt better then. Rhea's words reminded

me what, as a writer, I definitely have faith in: the power of story.

As one writer said, all we have is stories. It's what holds our life together. We call some stories science, some stories myth, but imagine hearing for the first time that the world may be round or that solid matter is mostly hollow. Such stories only become real when we believe them. And some stories are never supported with scientific fact, but they still seem to hold true.

For instance, ten years earlier, I'd dreamed that I should get a dog, and by that evening, Gracie, a goofy-looking gray mutt, came into my life. When people on the street would ask what her breed was, I would say Muppet wolf terrier. It was a breed I made up because I believed Gracie was a breed of her own, a fluffy half dog, half wolf.

So why not imagine now, as Rhea suggested, that she was off on an adventure exploring her wolf side?

The fourth day started with me finding a nickel on the sidewalk. I'd always thought of finding money as a good omen. And I was convinced it meant Gracie would come home on the fifth day. I guess it was another story to hold on to.

On day five, I was at a friend's house when her phone rang. I knew instantly it was news about Gracie. And I was right. Someone had found her in a downtown alley and had taken her in. Still, when I finally saw her in my hallway, her head lying quietly on her fluffy front paws, I cried. "My wolf days are over," Gracie seemed to say. "I'm back to being a dog."

Or so is the story I choose to believe.

NATHAN ALLING LONG *is a writer based in Germantown and an associate professor of creative writing at Stockton University in New Jersey. The recipient of a Mellon Foundation Fellowship, a Truman Capote Literary Trust Scholarship, and a Pushcart Prize nomination, Long has more than one hundred stories and essays published in journals and anthologies. His collection of short stories,* Everything Merges with the Night, *was a finalist for the Hudson Book Manuscript Prize and is currently seeking publication.*

My Place—Philadelphia

BRETT MANDEL

I BELIEVE IN A SENSE OF PLACE.

I grew up in Philadelphia and never really knew another place. I vividly remember when the time came to choose a college, I was intent on leaving, believing I would make my way in the world somewhere else, somewhere better. I spent the summer after graduating high school making my peace with the only place I ever knew, preparing to move on and never turn back.

But a funny thing happened to me once I was away. I recognized that all that I was had been shaped by Philadelphia and that I owed everything I was to that place. Philadelphia—my place—had shaped my worldview and had become a part of me.

Walking along cobblestone streets in Center City, I could see where the history I learned in school was made. Growing up among row after row of humble homes in the northeast, I learned the oddly Philadelphia addytude that endows me with a combination of a chip on my shoulder and an inferiority complex. Spending too much time in Veterans

Stadium and the Spectrum taught me that even when hopes are crushed, hope alone is reason enough to keep believing.

My sense of place is shaped by my understanding that the actions of a few revolutionaries can change the world; by my knowledge that, given a puncher's chance, one can overcome a rocky start to have a shot to become a champion; and by my certainty that no matter how close victory might appear (especially for my sports teams), defeat might be right around the corner.

But what was also part of my sense of place was the notion that Philadelphia was not the city I knew it *should* be and that, for too many, the place for which I had so much appreciation and affection was not a place of opportunity or a place of hope.

I knew then that I wanted, more than anything, to return home, to enjoy everything that is wonderful about Philadelphia, for which I owe a debt to those who came before me, and to help in the ongoing effort to fix everything that is not so wonderful so that others, including my own children, can enjoy an even better place.

Philadelphia is often a hard city to love, but for me it is always a hard city to leave. Now that I am able to travel more, I see other places and appreciate what makes them great, but my sense of place centers me and encourages me to live the oath taken by the citizens of ancient Athens. They declared, "We will transmit this city not only not less, but greater, better, and more beautiful than it was transmitted to us." That sentiment guides me and urges me to do what I can to make this a better place. Maybe that will inspire a sense of place in others who will do the same.

Lifelong Philadelphian BRETT MANDEL *is a citizen activist and nonprofit leader. Brett served as the director of financial and policy analysis in Philadelphia's Office of the City Controller, directed the efforts of the National Education Technology Funding Corporation and the citizens' advocacy organization Philadelphia Forward, and sought election for Philadelphia city controller. Mandel has also written* Minor Players, Major Dreams *(University of Nebraska Press, 1996),* Philadelphia: A New Urban Direction *(Saint Joseph's University Press, 1999), and* Is This Heaven? The Magic of the Field of Dreams *(Rowman and Littlefield, 2002). Mandel lives in Philadelphia's Fitler Square neighborhood with his wife and three children.*

Examining Life with Candor and Frankness

FREDERICA MASSIAH-JACKSON

I HAVE PRESIDED IN PHILADELPHIA'S CIVIL TRIAL COURTROOMS FOR nearly twenty years. Each day, our jurors, who are citizens, licensed drivers, taxpayers, or voters (or all of the above), sit and hear and see the real dramas of life. As the judge, I tell my jurors at every trial to "examine the issues and the evidence with candor and frankness."

I believe in the process of the jury system. I am always impressed with the jurors' capacity to maturely and thoughtfully reach a resolution. The jury's collective wisdom is grounded in their deliberations. Our jurors bring common sense to resolve life experiences.

After many years in the courts, I have adopted that same process of reexamining my views and changing my opinions about myself and others. Increasingly, I find myself looking inward with self-scrutiny and self-examination. I examine my own life experiences, my surroundings, and my goals in my personal and professional life. I, too, look at the evidence and the inferences, "freely and fairly with a sincere effort to arrive at a just verdict."

I remember celebrating my fifty-sixth birthday a few years ago. A messenger delivered a dozen yellow roses from a friend. My two children called to wish me well. But despite the smiles, I felt that it was an uncharacteristically serious birthday for me. I was now closer to age sixty than to fifty. And I instinctively knew that it was time to begin my own deliberations. Sure, I understood that "sixty is the new forty," but the reality of aging closer to that number is so much more than saying a catchy phrase.

And as I think about where I've been and what I am doing, I realize that I am following the advice and process that I have been providing to my jurors for so many years: "Your verdict should only be reached after careful and thorough deliberation."

I am looking at the second half of my life with a sense of transformation...an evolution. As the judge and the jury, it is not clear what the verdict will be; however, I know that this process of deliberation is exhilarating. I feel the tension within me and around me as I am considering new horizons and different directions. Life changes in ways that we can never anticipate. I believe that the process will bring a just resolution.

Judge FREDERICA MASSIAH-JACKSON *was elected to the Philadelphia Court of Common Pleas in 1983. A graduate of Chestnut Hill College and the University of Pennsylvania Law School, she practiced corporate and civil litigation with the law firm of Blank Rome before advancing to the bench. Judge Massiah-Jackson was a lecturer at the Wharton School of the University of Pennsylvania from 1992 to 2002. She also served as president judge from November 2000 to January 2006.*

What I've Learned Along the Way

Reverend Dr. Charles L. McNeil Sr.

I was born the third child, middle boy of four children in a South Philadelphia row home. My neighborhood was both beautiful and brutal. For me then, race was not a primary concern, survival was. Most of my teachers were white. I watched *Blondie*, *The Little Rascals*, and *The Three Stooges*. Rarely did I communicate with white people unless I walked to the 9th Street Italian Market only to be chased back across 10th Street, or when the white insurance man came to collect his monthly payments. All I knew then were black people—old, young, light, dark, poor—each day simply trying to survive. I didn't know it then, but my family was also poor, yet we ate each day.

My mother dropped out of school in ninth grade to care for her younger brother and sisters when her mother became sick. Eventually she got married, had two children, broke up, met my father, had me, broke up, met another man, had my younger brother, broke up, and raised us all by herself. To survive, she worked in bars, cleaned homes, collected food stamps, and eventually got a job that

she retired from after over thirty years employed there. Although she never graduated from any school, she taught me the rewards of hard work and determination.

During my childhood, most of the heroes in the neighborhood were corner boys, gangsters, pimps, number runners, drug dealers, or anybody who drove a purple Cadillac Eldorado with the diamonds in the back, sunroof top, diggin' the scene, with the gangster lean, ooh…ooh…ooh!

Like most of my young, fatherless friends, we all thought our destiny would eventually be like those we saw every day. In 1973, my father was killed. Some saw their father every now and then, drunk, lying on the front steps. But I could make up any story because my father was dead. I'd brag that he was killed at war fighting for his country, but he was killed in his apartment by a hired assassin connected to one of South Philadelphia's black drug gangs.

Third grade proved to be my time of self-awakening. My teacher had assigned me to do a report on George Washington Carver—you know him, the peanut man! And it awakened me to a world of black greatness I hadn't known before. After living in a neighborhood where only the worst was on display, I learned of black people who had made significant advances in this world. From then on, much of my time was spent examining life through the stories, struggles, and successes of black people. "Say it loud, I'm black and I'm proud" become more than a chant or even words from a song.

My first real experience with white people came when I attended an integrated high school. Not only was the school integrated, but each student was gifted with some artistic ability. I soon realized each of us was in a similar search for identity, and not only was I poor, but many of my classmates, black and white, were also. Somehow, there

seemed to be more commonality in us than our cultural differences suggested. So I ended up being the first in the family to graduate high school with honors; the first to go to college on academic scholarship; the first to buy a car; the first to buy a home; the first to have a successful and sustained marriage; the first to enter pulpit ministry; the first to enter and finish grad school; and the first to receive a doctorate, simply because I've learned to accept and love myself for who I am and how God made me.

I've found it easier to love others because I love myself. Now each day, my people inspire me to try a little harder, read a little more, go a little farther, and think a little bolder—because I believe that with God's help, there really is nothing we can't accomplish in life.

> *Reverend Dr.* CHARLES L. MCNEIL SR. *is a native of South Philadelphia. For many years he served as a creative director and university administrator. He is currently the pastor of Transfiguration Baptist Church and president of Manna Bible Institute in Philadelphia. He and his wife, Angela, have been married for more than twenty years and have three children.*

The Beginning of the Beginning

MARK MOBLEY

I BELIEVE THE BEST THINGS IN LIFE START WITH AN A. NOT THE first letter of the alphabet but the note from the oboe that tunes the orchestra as a concert opens.

I love lots of sounds that begin things—the ringing phone, the popping cork, "Gentlemen, start your engines." But nothing gives me the same thrill as the moment the houselights go down, the hall goes quiet, and the oboist plays her familiar solo. It's a long, steady tone like a call to prayer, or at least to peaceful assembly. She plays it once for the woodwinds and brass, once more for the strings, and then it's time for the conductor to enter and lead the rest of the music.

That silence carved out by the oboe is a field where a miraculous invisible building by Beethoven or Mahler or John Adams or Jennifer Higdon will stand, crafted by many hands with miraculous precision. It's said sometimes that classical music is a niche product—something only for rich people or snobs, the initiated elite. So why do so many of us return to it when we get married or plan a funeral? How

does it manage to inspire children, the elderly, and all ages in between?

I grew up in a house with just five classical albums, four of which were the 1812 Overture. I became a drummer in fifth grade and then went on to study percussion in college and spent many years as a music critic. I do tend to like what a friend calls "boy music"—loud and aggressive—but I'm also fascinated by hypnotic repetition and the extreme ends of softness.

To me, this variety helps make music the highest bandwidth form of human communication, with myriad points of entry and limitless possibilities. There have been great composers, but there are certainly more to come, and where they'll come from you can't predict. And no one can imagine what the music of the future will sound like. So the tuning note before a world premiere has an extra touch of drama.

Yet every orchestral performance opens with the A, or La, which is not just—as the song says—"a note to follow So." It's the note that begins a journey into the soul. Once the oboe and the orchestra are tuned, it's the listener's turn.

MARK MOBLEY *is a freelance writer, editor, and performer. For nearly twenty years he has worked for NPR in various capacities, serving as musical head of* Performance Today *when it won the Peabody Award. Called "breezily irreverent" by the* Washington Post, *he has performed and lectured with organizations including the Baltimore Symphony, Delaware Symphony, and the Virginia Arts Festival. When he wrote this essay, he was living in Wilmington.*

A True Public Servant

Mayor Michael Nutter

I BELIEVE IN THE GOODNESS OF PEOPLE AND IN THE LIFE-FULFILLING value of serving others. It's the right thing to do, but it's always been more than that for me. There's just no feeling I've ever found that compares with making a difference in someone else's life.

Some of my earliest memories are of my parents insisting that I show the best of manners, that I treat everyone fairly and not be judgmental. Once, when I was very young, my grandmother and I were walking down the street and we passed someone with a physical disfigurement. I turned back to look at him. My grandmother sharply scolded me about staring and making others uncomfortable. It was a lesson that stuck with me for the rest of my life.

When I was a little older, my father taught me about our responsibilities to each other. I grew up in West Philadelphia on Larchwood Avenue, and when it snowed, I had to shovel the sidewalk from my house past a half dozen other homes all the way down to the corner. When neighbors offered me money, I was not allowed to accept. Shoveling snow was my duty.

Later, at St. Joseph's Preparatory High School, I was a scholarship student and was required to do community service. I worked with the school's maintenance crew, tutored children at the Gesu Elementary School, and sometimes went back to my old elementary school and tutored students there.

After college, I worked at a nightclub, learning the business and spinning records as Mixmaster Mike. I met many of Philadelphia's rising political stars there, though I'd never considered politics myself as a vocation. One day my best friend, Robert Bynum, and I went to city hall and watched a city council session in that incredibly ornate chamber. I was fascinated by the political fireworks over two council members caught up in the FBI's Abscam probe; the clash of ethics and political power was riveting.

Later, I ended up at the office of Councilman John Anderson. He sat me down, and we talked for a long time. I've often reflected on how, without hesitation, he made time for me. Ever since, I've tried to follow his example.

From that first meeting, I began to volunteer and eventually became his campaign manager in a year of tremendous political change in our city. I went everywhere with him and saw parts of Philadelphia I had never seen before. I was amazed to see how people needed Councilman Anderson, how he was able to get things done for them, and how he gave them a sense of hope and restored their faith in government and its public servants.

After he won the primary in the spring of 1983, Councilman Anderson and I talked about my future. He urged me to run for city council in the next election. Unfortunately, just a few months later he died. My mentor was gone, but I understood that my life's work had just begun.

The Bible says that we all live in cities we did not build, we drink from wells we did not dig, and we reap from vineyards we did not plant. For people like me who have been given so much, it's our responsibility to help build a better world. That's what I believe.

> *Born in Philadelphia and educated at the Wharton School at the University of Pennsylvania, Philadelphia mayor* MICHAEL NUTTER *has been committed to public service since his youth in West Philadelphia. He served almost fifteen years on the Philadelphia City Council, earning the reputation of a reformer, before beginning his two terms as mayor in 2008. He is happily married to his wife, Lisa, and is a proud parent to Christian and Olivia.*

Finding the Human Spirit

Julie Odell

I BELIEVE IN THE HUMAN SPIRIT—THAT DRIVE THAT PUSHES US TO find the best within ourselves, the best within each other. My belief is fierce because for a long time I didn't have it at all.

I spent most of my twenties working in bars and nightclubs. These were jobs that paid the bills handsomely but did little to enhance a positive worldview. I saw people at their worst: drunk, conspiring, ugly in their motives. I was at my worst as well, smugly cynical, and I judged my customers as lacking in conviction when I had none of it myself. I'd grab their money without so much as a smile and feel the night wear me down until I believed I had the worst job in the world.

What still connected me to the me I'd been before the bars, to the me I'd always be, was my love of books. And of writing. Applying to grad school wasn't just the next logical step for someone like me with literary leanings. It was a way up and out, into the big, wide world outside of the bar.

In grad school, I taught at a state university, and my well-educated, middle-class students sat way back in their seats,

arms crossed, eyes glazed over. "Well, get on with it," their expressions said. "We have places to go." And so they did.

After grad school, I landed a job at a community college. And suddenly, I saw the human spirit shine. At community college, higher education is so often not my students' birthright, not what their high schools prepared them for nor what their neighborhoods encouraged.

At first I thought I'd just teach here for a few years, gather my bearings, and then head off for a PhD. After all, that was my birthright, wasn't it? But seventeen years later, I'm still here. This is where I belong.

The curiosity I see in my students' eyes, that beautiful glow of newborn confidence, delicate and tender yet tenacious as it grows, past failed quizzes and disappointments to hard-fought success—that is the human spirit.

I see it in Ricardo, an older student who always wanted to go to college. He sat in the back of the room, skeptical and irritated, until he wrote enough essays to see that he actually enjoyed turning a phrase and was quite good at it. And I see it in Tameka, a young woman who wasn't quite sure why she came to college, just that no one in her family ever had. She knew little about Russian history and cared even less, until she read *A Day in the Life of Ivan Denisovich* and the life of prisoners in a gulag illuminated her own brother's time at Graterford.

To me, community college is the great populist dream, to get it right this time, to move in a new direction, away from poor choices, dead-end jobs, a sense that things will always be the same. It does this for my students. And it did it for me.

I believe I have the best job in the world.

JULIE ODELL's short fiction has appeared in journals such as Five Chapters, New World Writing, Atticus Review, and, most recently, The Intentional. Additionally, she has completed three novels. She was a 2004 MacDowell Colony fellow. A member of the English department at Community College of Philadelphia since 1993, she is also the faculty advisor for Limited Editions, the student creative writing and photography magazine.

When All of Us Are Home

SISTER MARY SCULLION

WHEN I WAS A STUDENT AT ST. JOSEPH'S UNIVERSITY, I BEGAN TO spend time on the streets of Philadelphia, getting to know the men and women for whom these streets were their only home. The more I developed relationships with them and the more I got to know them, the harder it became to head home at night while they remained outside.

In time, I came to a powerful insight: When we see a person on the street we can no longer pass by and piously say, "There but for the grace of God go I"—but rather "There go I." As Dr. King taught us: "We are caught in an inescapable network of mutuality, tied in a single garment of destiny. Whatever affects one directly, affects all indirectly."

In this journey, I have had many great teachers—including Georgianna Simmons, who lost nine of her toes to frostbite, and who, despite a daunting mental illness, was a powerful advocate and woman of great love. Or Joe Williams, who turned his years of addiction into a passion for recovery and now, with a college degree, runs a recovery house for homeless men.

I've been doing this work for more than thirty years, and I've been radically changed. People who have nothing have taught me so much about life and grace, about faith and compassion.

Among the lessons they have taught me is that ultimately, people who are homeless need the same opportunities we all need: decent, affordable housing; quality education; employment; and access to healthcare. Their lives so eloquently witness the fundamental truth of the dignity of every person. Contrary to our society, which values those it deems productive and prosperous and often marginalizes those who struggle with homelessness, I believe that every man, woman, and child possesses gifts, worth, and potential. Everyone matters!

And so, I envision and work for a society in which each person is given the opportunity and resources to achieve their fullest potential and to contribute to the common good.

I also believe that our greatest power is unleashed when people come together across social boundaries to form a community united by a common vision. It is through "the power of we," as our friend and partner Jon Bon Jovi reminds us, that we come to know the deepest truth of our humanity.

This is what I truly believe: "None of us are truly home until all of us are home."

In 1989, Sister Mary Scullion co-founded the nationally recognized Project HOME, which provides supportive housing, employment, education, and healthcare to enable chronically homeless and low-income persons to break the cycle of homelessness and poverty. Her advocacy resulted in the right of homeless persons to vote and a landmark federal court decision regarding the fair housing rights of persons with disabilities. She received the Philadelphia Award and was selected by Time *magazine as one of the "World's Most Influential People" in 2009.*

Through Weakness Comes Strength

Darlene Sistrunk

I BELIEVE WEAKNESS IS NOT A SIGN OF FRAGILITY; IT IS THE POSTER girl for strength. I can appreciate the irony of what I just declared. Let me explain.

I'm a strong woman. Determined, focused, type "A" personality, left-brain champion. No tears for me unless I'm dangerously angry or watching *Terms of Endearment*, *The Color Purple*, or *Imitation of Life*. Accordingly, I keep a lid on my temper and officially declared a moratorium on watching those movies ever again. I know how to check my oil, tire pressure, and the truth meter on a mechanic. I can negotiate a good deal, motivate my children, and appreciate my husband. I am *woman* and many have heard me roar. The general consensus on me was pretty terrific, and I did not disagree.

Then one day my superpowers failed, and my armor got a big fat hole in it. My firstborn son was brutally murdered. When the professional yet compassionate detectives made the notification, I temporarily lost my balance on the front steps. Then, robotically and instinctively, I woke my husband, called my sister, and drove to my mother's home to break

the news to her in person. Shock can be a gift from God. In the twenty-four to thirty-six hours that followed, I identified his body, made phone calls, delegated errands, organized flowers, cards, and cash. Our son received a king's sendoff, and I was the only one who could do it for him.

No one had to tell me to be strong. Someone did have to tell me to be weak, and I didn't know how to give myself permission to do that—to come to terms with my own humanity and vulnerability.

Losing a child is an unbearable yoke. Losing a child to homicide strangles the life of a mother. I was a rock even to the point of my own crumbling. I had to fall to pieces so God could put our family back together and prepare us for the new normal.

Stroke victims may have to relearn speech and coma patients may have to relearn walking. This over-achieving, grief-stricken mother had to relearn the power of tears. Through my liquid cleansing, I am learning to grieve so I can eventually celebrate the life of my son.

In small, everyday doses, I take some time to smile about Justin. As I face the upcoming murder trial, I strive to laugh out loud every day at something Justin said or did so I don't retreat back to my emotionless fortress.

Justin loved math, sports statistics, Tupac, and Sam Cooke. He was proud of the grandfather he never got to meet and worried about the future. He was a happy new dad and a tired, old soul. Justin had a corny, cartoon laugh yet took his manhood and responsibilities very seriously. For the short, amazing, and challenging life we had together, I have earned the right to cry.

As I said, I believe that weakness is not a sign of fragility; it is the poster girl for strength.

DARLENE SISTRUNK *loves to find joy in her everyday existence as the best route for survival. That path was severely detoured when she lost her oldest son, Justin, to gun violence six years ago. However, submitting to the human weakness of tears, Sistrunk found strength and eventually reclaimed joy. A recruiter by profession, Sistrunk is most proud of being a minister, poet, and community activist. She lives in Southwest Philadelphia with her husband, children, and granddaughter.*

What's My Story?

KARINA SOTNIK

I BELIEVE THERE ARE NO SIMPLE ANSWERS TO QUESTIONS LIKE "Where are you from?" or "What do you do?"

Take my example. "Where are you from?" always make me cringe, because I know exactly how the conversation will progress from there. Someone hears me rattling away in "a foreign language" with my husband, my kids, or my friends and inevitably asks, "What language are you speaking?" "Russian," I answer.

"Oh, so you are from Russia?"

"No, I am from Latvia."

"Ah, so you are Latvian?"

"No, not really..."

At this point I know that, circumstances permitting, I will have to take a little time to explain myself. You see, even though my family lived in Latvia for generations, and even though my family language is Russian, I am neither Russian nor Latvian. I am, as my husband—a professor—puts it so eloquently, a "Russian-speaking Latvian Jew."

This statement always raises an eyebrow: "What does Jewishness have to do with any of this?" Well, you see, in my passport, growing up, in the space marked "nationality" (yes, Soviet passports had such a space) I was defined as neither Russian nor Latvian but rather as "Jewish."

For me, Jewishness is a culture and an ethnicity and not so much a religion. I have rarely set foot in a synagogue—to the sincere dismay of my "real" Jewish friends here.

While I love the Russian language, love to read and speak it; and while I set the table like a true Latvian (tablecloths, napkins, the whole thing), at the deepest level I am Jewish.

I find myself in a similar situation when faced with the "What do you do?" question.

I have an engineering degree and I used to work for software companies in Silicon Valley; however, I relocated to Philadelphia eight years ago and opened a high-end linen boutique. Now, after the recession brought me to close the boutique, I advise companies on how to expand their business internationally. Try to summarize that in a short, witty answer.

My situation is hardly an isolated case or a product of the recent era of globalization. Think of all those ancient Christian Arabs who lived in Jerusalem. Or take my good friend Ligia, a Romanian-born Israeli French transplant to Philadelphia, a prominent architect, turned professor, turned therapist, turned published novelist.

My pre-teen children, if asked the same sort of question, will cheerfully tell you that they are Russian-American-Christian-Jews. They don't see anything strange about it, and neither do many of their classmates.

I believe, therefore, that we should stop asking impossible-to-answer fill-in-the-blank questions like "Where are you from?" and "What do you do?" Those are for census forms

and Soviet passports. Instead, we should ask more open-ended questions like "What's your story?"

KARINA SOTNIK *was born in Riga, Latvia, in 1965. She lived and worked in California in Silicon Valley for over a decade and is now living in Philadelphia with her husband and two daughters. She is a serial entrepreneur, advisor, and educator focused on providing mentorship, consulting, and advice to startups in academic incubators in the United States, Scandinavia, and Russia. Additionally, her translations of Russian poetry have been published in* World Literature Today *and* Common Knowledge, *as well as in other publications.*

I Believe in Philadelphia

SOZI TULANTE

DECEMBER 15, 1983, IS A DATE INDELIBLY ETCHED IN MY MEMORY. I was eight years old, it was my first day in America, and I was crossing the Delaware River into Philadelphia. On that chilly, cloudless evening, I caught my first glimpse of downtown Philadelphia, impressed by the cavalcade of lights radiating from its imposing skyscrapers jutting high into the sky. We were a motley crew—me, my two younger siblings, my father, and my mother, who was nine months pregnant with my sister, born a week later.

My family was on the final leg of a seven-thousand-mile trek that began two days before in our home in Kinshasa, Zaire, when we were rushed to the airport in the middle of the night to avoid any detection by the secret police. Our trip was only possible because, after my father's release from his brief but brutal detention as a political prisoner, the United States had mercifully ended our nervous wait for a safe haven by granting us asylum.

I vividly recall the indescribable blend of wonder, trepidation, and anticipation I felt about what lay ahead:

forging new friendships, settling in a new home, learning a new language, all a world apart from virtually everyone and everything I had ever known.

At first, things couldn't have been worse. We lived in parts of North Philadelphia that had suffered the twin scourges of a raging crack-cocaine epidemic and senseless gangbanging. I often went to bed overwhelmed by hunger, even though my parents had swallowed their pride and reluctantly accepted welfare.

While our climb was steep, we eventually crafted a place for ourselves in Philadelphia, thanks to my parents' steely determination and unrelenting faith in the promise of this city. After all, its public schools instilled in my siblings and me a thirst for knowledge that lifted each of us to college, and me to Harvard and Harvard Law School. Its hospitals supplied a new liver for my father; and, of course, from that sullen, wintry night until today, this city has been our sanctuary.

So, I believe in Philadelphia. Not just its people, thoroughfares, or parks, nor its sports teams, with their knack to frustrate and uplift their devoted fans in equal measure. I mean the spirit of a city that, beginning with the Quakers, has offered to heal the shattered lives of those escaping persecution. This belief is deeply rooted in the improbable arc of my family's story and those of countless others like us.

Today, as I admire the mischievous smiles and wonderful babbles of my seven-month-old son Kiese, I know that this belief is real. And years from now, perhaps he, too, will embrace it and proudly and loudly proclaim, this, I believe.

SOZI PEDRO TULANTE *is an attorney in Philadelphia. He received his JD, cum laude, from Harvard Law School and his AB, cum laude, from Harvard College. He grew up in Congo and North Philadelphia, went to Northeast High School in Philadelphia, and lives in West Philadelphia with his wife and three kids. He continues to pass on to his children the lessons he learned from his late father, Manuel Sozinho.*

Appendix

The following list contains all the Philadelphia essayists that we know of whose essays were broadcast during the 1950s *This I Believe* radio series. We have included both those who were native Philadelphians but were living elsewhere at the time they wrote their essay, as well as those who were raised elsewhere but lived in the Philadelphia area at the time of their *This I Believe* broadcast. The text of these essays, as well as many of the original audio recordings, can be found at the website thisibelieve.org.

Allman, Robert G.	Insurance broker; president National Blind Golfers Association
Annenberg, Walter H.	Editor and publisher, *Philadelphia Inquirer*
Bagnell, Francis James	Student, University of Pennsylvania
Barrymore, Lionel	Actor, native Philadelphian
Beitzel, George B.	Businessman
Benfey, Theodor	Assistant professor, Haverford College
Burk, Joseph William	Crew coach, University of Pennsylvania

Campbell, Bill	Radio and television sportscaster
Carey, James	Labor leader, native Philadelphian
Clement, Martin	Director and former president, Pennsylvania Railroad
Cobbs, Susan Parker	Professor, Swarthmore College
Ely, Van Horn	Vice-president, Philadelphia Suburban Water Company
Evans, Harold	Attorney
Evans, Robert Arthur	Student, University of Pennsylvania
Fowler, Burton P.	Principal, Germantown Friends School
Fox, Cyril G.	President, Fels & Company
Fox, Thomas P.	Dentist
French, Paul Comly	Executive director, CARE
Griffith, Ivor	President and research director, Philadelphia College of Pharmacy and Science
Gummere, Richard M.	Educator, William Penn Charter School, Harvard and Haverford Colleges
Hall, Edward	Headmaster, Hill School
Hamilton, Edith	Author and classicist
Hecht, Edith	Sculptor
Hires, Charles E., Jr.	Chairman of the board, Charles E. Hires Co.
Hodges, Leigh Mitchell	Journalist and columnist, *Philadelphia Bulletin*
Hoskins, Lewis M.	Executive secretary, American Friends Service Committee
Hottel, Althea Krantz	Dean of women, University of Pennsylvania
Hubben, William	Author; editor of the *Friends Intelligencer*

Ingersoll, C. Jared	Director, Pennsylvania Railroad
Jacob, Betty Muther	Human rights activist
Johnson, Eric Warner	Author; headmaster, Germantown Friends School
Kelly, John B. "Jack"	Businessman; Olympic rower
Kimball, Maulsby	Painter; art director, Bryn Mawr Art Center
Lester, John	Retired headmaster, Hill School
Levinthal, Louis E.	Judge, Philadelphia Court of Commons
Loescher, Dr. Frank	Sociologist; director, Philadelphia Fair Employment Practices Commission
Lutz, Jack	Former advertising director, W.B. Saunders & Company
Mann, Edward M.	Vice-president, Philadelphia National Bank
McDevitt, George	Advertising executive, native Philadelphian
McFeely, Richard	Headmaster, George School
McVey, James Lewis	Insurance broker
Mead, Margaret	Anthropologist, author
Michener, James	Author
Millen, Herbert E.	Judge, Municipal Court of Philadelphia
Nason, John W.	President, Swarthmore College
Nesbitt, Albert J.	President, John J. Nesbitt Company
Norton, Nicholas	Student, Haverford College
Petersen, Howard C.	President, Fidelity Philadelphia Trust Company
Phipps, Anne	Student, Bryn Mawr
Pickett, Clarence E.	Former executive director, American Friends Service Committee

Read, Conyers	Professor, University of Pennsylvania
Richie, David S.	Executive secretary, Friends Social Order Committee of Philadelphia
Richmond, Ralph	Advertising executive
Roosevelt, Theodore, III	Stockbroker
Saul, Dr. Leon J.	Psychiatrist; professor, University of Pennsylvania School of Medicine
Schauffler, Bennet F.	Labor leader
Sears, William	Broadcaster
Sharples, Laurence P.	Founder, Aircraft Owners and Pilots Association
Slater, Verona Wylie	Homemaker
Stassen, Harold E.	President, University of Pennsylvania
Stevens, Lewis Miller	Attorney
Supplee, Henderson, Jr.	Executive vice-president, Atlantic Refining Company
Thayer, Eliza "Lilah" Talbott	Sculptor
Thayer, Frederick	Banker
Thomas, Dorothy	Writer, native Philadelphian
Toland, Edward D.	Retired educator, native Philadelphian
Underhill, Irvin Windfield	Minister
Vining, Elizabeth Gray	Author; tutor of crown prince of Japan
Weeder, Dr. S. Dana	Surgeon
Wheelock, Keith	Diplomat, State Department
White, Gilbert F.	President, Haverford College
Williams, Alfred Hector	Banker and educator
Winsor, Curtin	Attorney
Wolf, Alfred	Attorney; examiner, Civil Aeronautics Board

Acknowledgments

FIRST AND FOREMOST, WE WOULD LIKE TO OFFER OUR DEEPEST thanks to the essayists who have contributed their personal statements to this book. We honor their willingness to explore and express the things that matter most in their lives and then share those beliefs here in this book.

In reviving the This I Believe project, we owe an enormous debt of gratitude to Casey Murrow, Keith Wheelock, and Margot Wheelock Schlegel, the children of This I Believe founders Edward R. Murrow and Ward Wheelock. Our project continues to be guided by Ward Wheelock and his team, which preceded us in the 1950s. We are grateful to those who worked to bring the 1950s essays in this collection to fruition: Robert De Pue Brown, Gladys Chang Hardy, Reny Hill, Donald J. Merwin, Edward P. Morgan, Ralph Richmond, and Raymond Swing.

Our special thanks to Leadership Philadelphia, which originally conceived of a local This I Believe project in Philadelphia, and deep gratitude to public radio station WHYY, where all of the contemporary essays were edited,

produced, and broadcast. Specifically, we'd like to thank
Leadership Philadelphia's executive director Liz Dow,
who commissioned many of the contemporary essays in
this book, and board member Ed Tettemer, who helped
edit several of the essays. At WHYY, we offer sincere
thanks to President and CEO Bill Marrazzo, Executive
Vice-president and Chief Operating Officer Kyra G.
McGrath, Vice-president and Chief Content Officer
Christine Dempsey, Vice-president for Communications
and Member Relations Art Ellis, and Community
Relations Coordinator Brittany Smith, with our deepest
and sincere appreciation to Executive Producer of Audio
Content Elisabeth Perez-Luna, who oversaw the *This I
Believe—Philadelphia* radio series at WHYY. We are indebted
to her for the many years of passionate, dedicated work in
bringing the beliefs of Philadelphia to air.

A hearty thank you to Meg Thayer and Sue Toland,
grandchildren of 1950s essayists Frederick and Eliza Thayer,
who volunteered many hours helping research the lives of
1950s essayists, reaching out to their living relatives, and
planning promotional activities for this book. Along the
way, they recruited their respective parents Harry Thayer
and Mitsie Thayer Toland to help answer questions about
Philadelphia in the 1950s.

We would also like to thank the good folks at the City
of Philadelphia Mural Arts Project for providing us with
the wonderful photograph of their *This We Believe* mural that
graces the back cover of this book. After holding community
meetings across the city to discuss the beliefs of the citizens
of Philadelphia, this large mural was created in the train
station, and then later its panels were donated to schools.
Our thanks to executive director Jane Golden, special
events manager Amy Johnston, and artists Eric Okdeh,

Kien Nguyen, and Michelle Angela Ortiz for creating this work of art and sharing it with us.

Without our funders, this book project simply would not have been possible. We would like to thank our generous donors Mayra Alvarado, Karen Bailis, Robert Caiola, Maryanna Jones Kline, Alix Toland, Helen Wheelock, and the family of Eliza T. Thayer and Frederick M. Thayer, as well as a handful of generous citizens who wish to remain anonymous.

We offer our special thanks to Maggie Gediman for her diligent research assistance on this project.

Our publisher, The History Press, has been tremendously supportive of our recent publishing activities. Our hats are off to editor Adam Ferrell for making this process as painless, indeed as pleasurable, as possible. We'd also like to thank Bob Barnett for the initial contact, Anna Burrous for a beautiful book cover, Hilary Parrish for expert copyediting, and Katie Parry for publicity support, as well as Robby Rankin and Adam Kidd for their salesmanship.

DAN AND MARY JO GEDIMAN, EDITORS

About the Editors

DAN GEDIMAN IS EXECUTIVE DIRECTOR OF THIS I BELIEVE, INC., a nonprofit organization that engages people in writing and sharing stories describing the core values that guide their daily lives. These short statements of belief have been featured on public radio, on the web, and in print since 2005, and the essay collection of more than 150,000 statements of belief can be found at thisibelieve.org. Gediman is the coeditor of the *New York Times* bestseller *This I Believe*, as well as *This I Believe II* and six other collections of This I Believe essays. A thirty-year public radio veteran, his work has been heard on *All Things Considered*, *Morning Edition*, *Fresh Air*, *Marketplace*, *Jazz Profiles*, and *This American Life*. He has won many of public broadcasting's most prestigious awards, including the duPont-Columbia Award.

MARY JO GEDIMAN HAS WORKED IN PROFESSIONAL communications for more than twenty-five years as a writer, editor, and project manager. Since joining This I Believe in 2006, she has worked collaboratively to extend the reach

roject into secondary schools, colleges/universities,
systems, public radio stations, newspapers, and local
unities nationwide. Gediman is an editor of the award-
ing This I Believe website and is co-editor of the books
I Believe: On Love, *This I Believe: On Motherhood*, *This I Believe: On
therhood*, *This I Believe: Life Lessons*, and *This I Believe: Kentucky*.

ELISABETH PEREZ-LUNA HAS BEEN WORKING AS A JOURNALIST AND independent audio producer for National Public Radio and other news and documentary networks for several decades. She has been at WHYY since 1999, first as news director and now as the executive producer of audio content. She is the producer of special series such as *This I Believe— Philadelphia*, *Impact of War—Pennsylvania*, and other programs, sound portraits, audio environments, and features for radio and web. Perez-Luna has received numerous awards for her national and regional work.